CONTENTS

Introduction	2
A Manifesto For Sepia Saturday	3
Alan Burnett : The Curious Case Of The Milliners' Wedding	4
Alex Daw : Bicycles And Caps	5
Barbara Finwall : I Was A Female "Mad Man"	5
Barbara Rogers : Eugenia Booth Miller, 69 Years Before Me	7
Barbara Turner (Boundforoz) : What The Children Didn't Know	9
Bob Scotney : Connexions – The Durham Ox To Daffodils	7
Brett Payne : Ready With The Bulls-Eye, Come Rain Or Shine	11
Bruno Laliberté : This Is My Mom	13
John Brindley (Caminante) : Caminante Revisited	14
Colleen G Brown Pasquale : Things That Float	16
David M Lynch (Silver Fox) : Technology – A Sepia Saturday Post	65
Dee Burris Blakley : She Made Hats	17
Doug Peabody : The Adventures Of Fran And Bunt	18
Helen Bauch McHargue : On Itchiness	20
Howard Webb : London Bridge, City of London, Early 20th Century	21
Jennifer Geraghty-Gorman : The Sea Of Love	22
Jackie McGuinness : Gloves, Bonnets And Penetrating Gazes	24
Jackie van Bergen : A Family Of Picnics	26
John Foster : Something A Little Different	28
Karen Sather : Happy By The Nature Of Their Smile	28
Kat Mortensen : Katie Revisited	30
Kathy Matthews : The War Letters – Uncle John Visits A Cemetery in Natal, Brazil	31
Kristin Cleage : Growing Up In Her Own Words by Doris Graham Cleage	33
Gail Perlee (La Nightingail) : Reading Newspapers, Magazines, Books & All	36
Larry Burgus : My Family	38
Lorraine Phelan : Flowers And Crosses	39
Marilyn Brindley : Open All Hours	40
Martha Gibbons : Edith A Nunn	42
Martin Hodges : Mr & Mrs Light Come To Town	42
Mike Brubaker : A Band For Juneteenth	44
Nancy Javier : Mayday, Mayday, Mayday	48
Nancy Messier : Refreshing An Indelible Image	47
Nigel Aspdin : The Spy Who Stayed Out Of The Cold	49
Patricia Ball Morrison : Frank Ostrowski	51
Peter Miebies : The Watchman	53
Postcardy : Post Office & Restaurant – Chandler, Minnesota	55
Rietje de Jong : The Mending Workers In Scheveningen, Netherlands	56
Rose Theriault : Sisters On The Beach	57
Sean Bentley : X Marks The Spot	59
Sharon Fritz : AHS Wanganella	62
Susan Donaldson : A Stretcher Bearer In The Field	58
Tattered And Lost : Seaplanes Take Flight	66
Terri Buster (Colouring Outside The Lines) : Health Resorts And Dolls	16
Tony Zimnoch : How To Hate The Working Class	68
Wendy Mathias : Breaking The Ice	69

SEPIA SATURDAY 156
15 December 2012

INTRODUCTION

Like all good things, Sepia Saturday started as a joke. In writing a Theme Thursday post way back in October 2009, I needed something to cuddle up - in an alliterative sense - with Wordless Wednesday and Fun Friday, so I invented Sepia Saturday. My Blogging friend Kat (Poetikat) Mortensen asked me whether there really was a Sepia Saturday and I had to confess to my invention. We both agreed that even if such a celebration didn't exist, it should do and therefore resolved to introduce it without further delay.

On the 28th November 2009, the first two Sepia Saturday posts was published – one from me and one from Kat. By the following week there were five participants and within a few weeks that number had more than doubled. By February 2010 – Week 11 of Sepia Saturday – Kat and I agreed that Sepia Saturday was going to be more than just a short-term experiment and we also agreed that it needed a permanent home of its own. And so the Sepia Saturday Blog was established, and it has been attracting bloggers from around the world ever since.

Sepia Saturday was always meant to be fun and was always going to be slightly anarchic – neither Kat nor I were over-fond of rules. But there was a serious side as well and we tried to capture a little of that in the Sepia Saturday Manifesto which we published in February 2010 (and which is reproduced on the next page). We recognised that we were the first generation to have access to the technology that could both preserve and disseminate those carefully guarded family photographs that said so much about the life and times of our ancestors.

And so Sepia Saturday began to grow and to develop. Whilst those early weeks had been based on a free-for-all approach in terms of subject matter, slowly the idea of a weekly theme emerged. It was, however, central to the ethos of Sepia Saturday that such themes should be image-based and therefore providing the maximum opportunity for interpretation and improvisation. Before too long a Sepia Saturday Facebook Group also developed which allowed regular participants to exchange ideas and discoveries. And before we knew it, we know longer had a group, we had a family.

It is quite a remarkable family. At one time or another it has included participants from every continent other than Antarctica, and it regularly brings together people from more countries than an average meeting of the United Nations. Those participants – the Sepians as they have become known – support each other, and share their words, their images, and a slice of their lives on a weekly basis.

To celebrate the 200th week of Sepia Saturday it was decided to invite participants to republish their own favourite Sepia Saturday contribution. This book is a compilation of those contributions which, I believe, illustrates the broad range of approaches and styles that make Sepia Saturday such a pleasure to be part of.

Of course, undertakings such as Sepia Saturday cannot succeed without the hard work of a large number of people. I would like to thank all the people who have contributed their work to this celebratory book, and who have supported Sepia Saturday on a weekly basis. In particular I would like to thank Kat Mortensen who helped me launch Sepia Saturday all those years ago and Marilyn Brindley who helps me administer the group now and who, with the help of Bruno Laliberte, looks after the Sepia Saturday Facebook Group.

Let me finally say that, if this little book is to be dedicated to anyone, let it be dedicated to those faded Sepia faces that inhabit our collective photographic albums, those faces from long ago, those people who still have a fascinating story to tell.

Alan Burnett
West Yorkshire, UK : November 2013

A MANIFESTO FOR SEPIA SATURDAY

1. We belong to a favoured generation: the first generation of the digital age. Whilst our ancestors have valiantly attempted to preserve their own unique history in scraps of written narrative and faded and creased photographs, we have the unique ability to fix these memories for ever as our legacy to future generations.

2. Scanning, blogging and digital storage provide us with the means of preserving the past, but we also have a duty to preserve the stories and images of those that contributed to our society as we know it. Whilst we can leave to academic historians the task of documenting the lives of the rich and famous, we believe that the most remote second-cousin and the most distant of maiden aunts has made a unique contribution to the lives that we lead. Each one of us has a duty to help preserve the stories of these builders of the modern world.

3. Whilst images alone are fascinating documents, images with words - be they simple half-remembered names and dates or gripping narrative histories - are even better. The synthesis of image and words provides the most effective insight into the past.

4. "Sepia" is an alliterative convenience rather than a descriptive criterion. Let our images be in sepia, in black and white or in full colour : what matters is the message and not the medium.

5. We recognise that we have not only a duty to share our past but also to ensure that it is effectively preserved. Whilst images printed on photographic paper and words written in old notebooks fade with time, they have proved, in most cases, remarkably resilient over time. Perhaps one of the greatest dangers facing the millions of digital images and the endless pages of computerised words we produce today is that they can so easily be lost by the pressing of a wrong button or by the hacking of a troubled soul. We recognise and we accept our responsibility to back-up and securely save.

The images used in this book come from the various blog posts that were submitted for the Sepia Saturday 200 celebration. Other images are taken from the collection of prompts used by Sepia Saturday over the last four years. All material remains the copyright of the individual contributors.

Alan Burnett : News From Nowhere

THE CURIOUS CASE OF THE MILLINERS' WEDDING

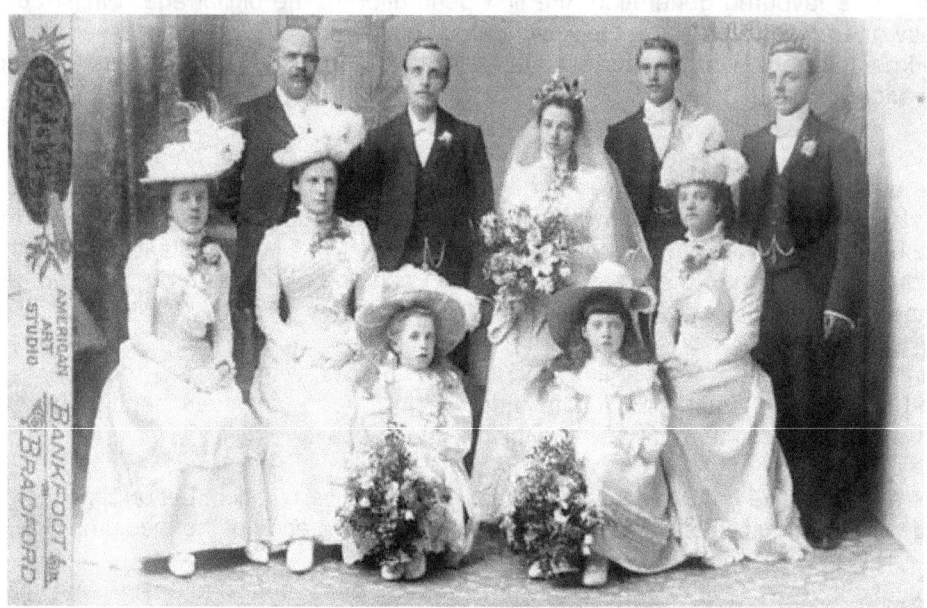

Irrespective of anything else, this is just a gorgeous photograph. Again it came out of one of those boxes of old photographs which are handed down. There are no firm details as to who the subjects of the photograph are other than a scribbled note in pencil on the back which states "Harry's Father". I must confess that the handwriting looks suspiciously like mine and therefore it appears that at some stage, I half identified the happy couple and then abandoned them to a fate of dust and scratches at the bottom of an old cardboard box. For this I feel guilty and I am therefore determined to make some amends. I need to track down the details and release them to the waiting world. It will be like one of those wedding reports you see in the local paper. The difference will be that it will be a little late in appearing (as it turns out, 108 years late).

The Harry was the clue, for as regular readers of the Blog will know, I had an Uncle Harry. He was married to my father's sister and was therefore not a direct blood relative of mine. Luckily, amongst the various documents I have accumulated over the years, I have a copy of his birth certificate. He was born in 1903 and his parents were Abraham Moore and Alice Moore (formally Rotheray). So the chances are that this could be a photograph of Abraham and Alice's wedding. The one problem with this is that they all look a little too affluent. Abraham is listed on the birth certificate as being a "Piece Taker In" which sounds as though it is a run-of-the-mill textile process. Could a Piece Taker In have afforded those magnificent hats or attracted a girl from a family that could? The census records suggest that Alice's father was a "Butter Factor" : once again not likely to be able to afford all those ribbons and bows.

The crowning piece of evidence was in the 1891 census records. By now Alice is 16 and her occupation is listed as being a "Milliner Apprentice". We therefore have a possible solution - the hats were stock in trade, borrowed for the big day from the bride's workplace. Whatever the explanation, it does seem likely that it was the wedding of Abraham and Alice which took place in the Spring of 1900. So, a little late in the day, we can finally publish the picture, and the report :

```
"The wedding took place on Saturday 23rd April 1900 of Abraham, son of Smith and Margaret
  Moore of Percy Street, Horton, Bradford and Alice, eldest daughter of Thomas and Lydia
Rotheray of Smiddles Lane Bowling, Bradford. The bride wore a dress of starched white silk"
```

One time lecturer, writer on European Affairs and bus conductor, Alan Burnett now divides his time between walking the dog and a little harmless blogging. His News From Nowhere Blog has been running since 2006 and acts as a showcase for his ranting and writing and his photographs old and new.

Alex Daw : Family Tree Frog

BICYCLES AND CAPS

I am a Johnny come lately to Sepia Saturday having only been aware of its existence since February this year and having made the grand total of 20 contributions. I have chosen my first contribution (Sepia Saturday 162) largely because it is short and sweet and also because it is a photo I love but know absolutely nothing about...the best kind ! The theme was bicycles or lads with caps on their heads.

This photo was in my grandfather's album (Thomas McLoughlin) so I am hazarding a guess that it was taken in Bathurst or Orange in the early 1900s.

What these lads were doing I have no idea...feel free to extemporise.... Hanging about on a Sunday I reckon. Happy Anniversary Sepia Saturday!

Alex Daw is from Brisbane Australia - a family historian and an L-Plate Librarian with a love of photography and blogging.

Barbara Finwall : Banar Designs

SEPIA SATURDAY- I WAS A FEMALE "MAD MAN"

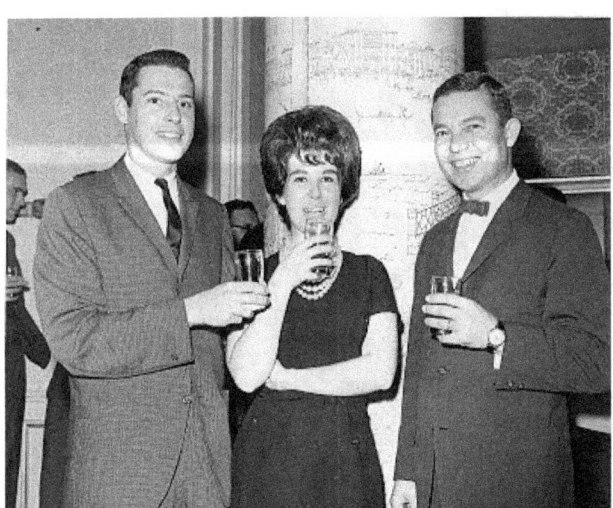

If any of you watch the T.V. series "Mad Men" this photo will probably look like part of the show. (That's me, with the big hair.) I worked at an ad agency in the early 60's and, I swear, the stories on "Mad Men" came right out of this agency, Hixson and Jorgensen, and the next agency I worked for, Faust/Day.

I was about 22 in this photo and working as a paste-up artist which would be the precursor to being an art director if you were a man. At Hixson and Jorgensen it was the stated policy that women couldn't be art directors. Luckily, my fellow paste-up artist, Dennis Juett, (on my left) moved on to a wonderful new agency (Faust/Day), where he became an art director and soon hired me as an art director, also.

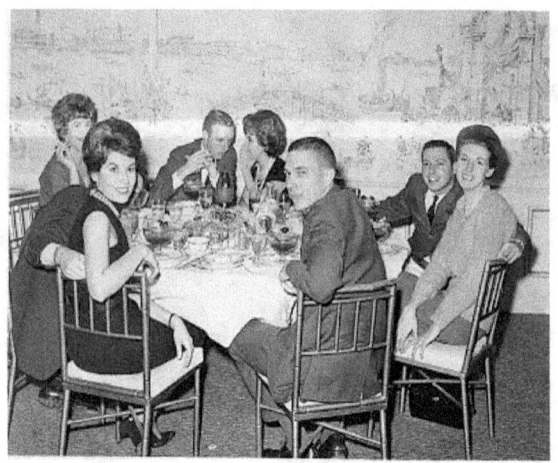

If you watch "Mad Men" you'll recognize "Joan" in the black dress- the office glamour girl. This was at a Christmas party held at the Ambassador Hotel, just down the street from our office on Wilshire Blvd. (That's me in the back, spreading office gossip.)

This must have been a different party because I have a different outfit on- very chaste, just like "Peggy" on "Mad Men", who reminds me of me in lots of other ways. Notice the woman in the "tres chic" white suit with the long black leather gloves, harlequin glasses and requisite cigarette. She walked by my cubicle one day while I was working on a "Nixon for Governor" ad. It was very misleading (not my idea, of course). She was appalled (so was I). She whisked it off my drawing board and took it to Democratic headquarters. It was in the paper the next day. For some reason neither of us got fired. He did lose, though. Did I have a hand in that? That ad was nothing compared to all the really misleading ads of today.

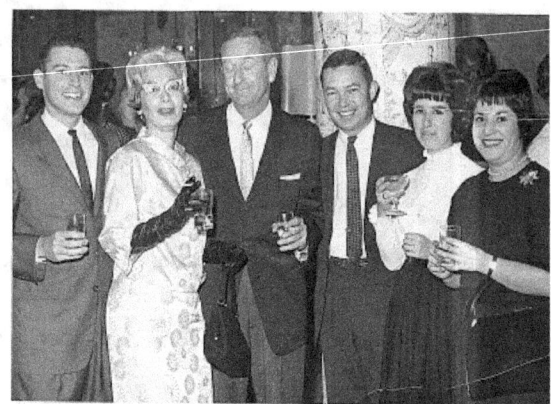

Why the cigars? I think someone in the office must have had a baby. The cute guy with the pipe was the office Lothario. I did go out with him once but it went no farther than that. He was pretty stuck on himself.

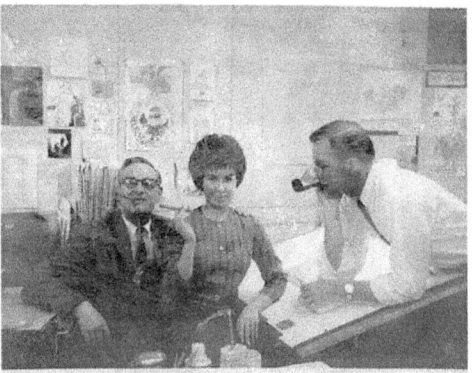

Barbara Finwall : I've been participating in Sepia Saturday for the last 3 years. I'm retired from the publishing business and before that the advertising biz. Now I live on a small avocado ranch in Fallbrook, CA. I enjoy watercolor, collages, art classes, the theater, reading, films, photography, genealogy and animals.

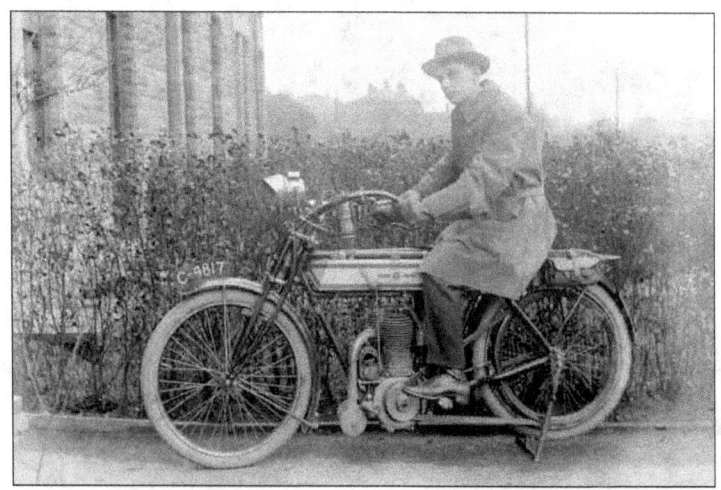

Sepia Saturday 51 : 25 November 2010

Barbara Rogers : When I Was 69

EUGENIA BOOTH MILLER, 69 YEARS BEFORE ME

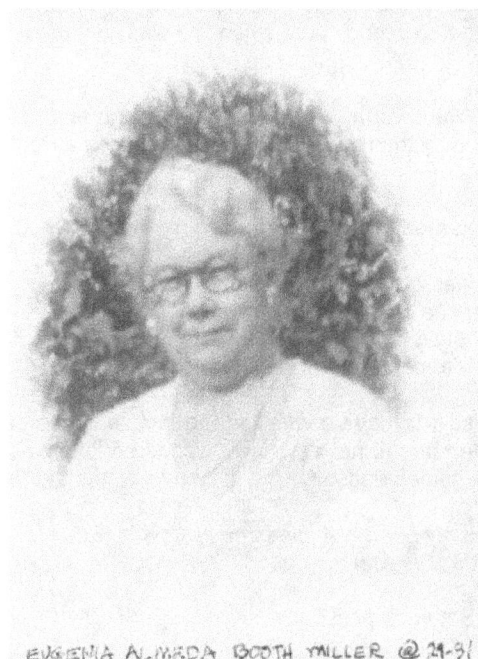

EUGENIA ALMEDA BOOTH MILLER @ 29-31

Since there are more things known about the past than the future, let's consider my ancestors relative to 69 years, (the magic number of my age that this blog is memorializing.)

That's why time traveler stories touch only briefly on a future, and a lot of past times. So if I look back to an ancestor that would have been 69 in 1942 (the year I was born) ...they would have been born in 1873. Mmm, I dare say I can look on the good old family tree and find someone. It doesn't matter if they didn't actually live to 69, because it's the magical birthday I'm tracking this time. (In the future I'll check and see how many ancestors did make it to the year of their 69th birthday)

Oh my goodness...the woman I was named after was born Jan 30, 1873. She was my great-grandmom, Eugenia Almetta (Almeda) Booth Miller, and she died Jan 1, 1936. She raised my mom and my grandmom, and had married Charles Mueller (Miller) October 28,1896, an immigrant from Germany. They had 4 daughters, including my grandmother, Mozelle Booth Miller. I was named Barbara Booth, rather than Eugenia.

I'm going to share this great news (well, only if you put a parameter on history that says, look at it this way...) on Sepia Saturday this week. See what other folks are sharing here.

Barbara is retired from salaried work, and now overworks as a volunteer and diligent clay artist, publisher of 3 blogs, photographer, grandmother, and caregiver of 2 cats. My blog "When I was 69" started as a way to keep my friend's and my own stories alive, and morphed into keeping the lives of my ancestors available through their birthdays.

Bob Scotney : Bob's Home For Writing

CONNEXIONS – THE DURHAM OX TO DAFFODILS

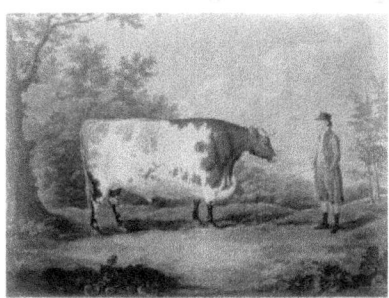

The Durham Ox was bred in 1796 by the pioneering shorthorn breeder, Charles Colling of Ketton Hall, Bafferton, Nr Darlington in the North East of England. The beast became known as the Ketton Ox when it was exhibited in Darlington in 1799.

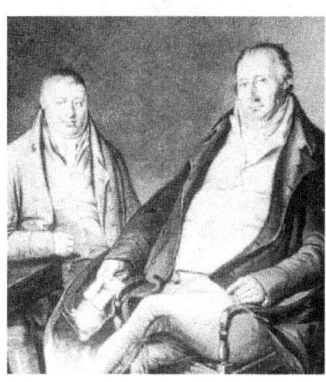

The Colling brothers and a man named Thomas Bates, who farmed at Kirklevington, have been given much credit for the development of the Durham Shorthorn breed of cattle.

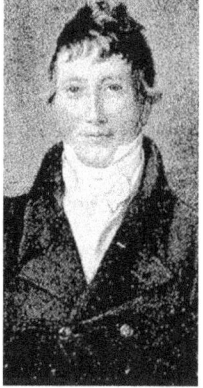

The Kirklevington estate in what is now North Yorkshire has been owned over the centuries by such aristocratic and royal landowners as William the Conqueror, Robert de Brus, The Percys, Henry IV and Henry V. It was finally divided and sold by the Earl of Strathmore to two wealthy business men one of whom was Henry

Hutchinson who was mayor of Stockton-on-Tees for a time. His nephew, John, bred shorthorns at Stockton and named one of his bulls "Kirklevington."

In their childhood John and his brothers and sisters became wards of Henry Hutchinson. In their early childhood before they were orphaned the Hutchinsons had been friends and neighbours of the Wordsworth family at Penrith. Mary Hutchinson had been born at Stockton-on-Tees and went to school there when she was sent to live with her Uncle Henry.

At twenty-four Mary announced she was going to marry William Wordsworth. Her uncle did not approve; he considered Wordsworth had no profession – he had changed his mind by the time Wordsworth had become Poet Laureate.

William and Mary were married in 1802. William wrote a poem about his wife in 1803.

'She was a Phantom of delight
When first she gleamed upon my sight;
A lovely Apparition, sent
To be a moment's ornament;'

But it was Mary who is said to have composed the last two lines of Wordsworth's often quoted poem; he may have 'wandered lonely as a cloud' to see 'A host of golden daffodils;' but its Mary's words at the end:

'And then my heart with pleasure fills,
And dances with the daffodils.'

So why is this my Sepia Saturday post?

 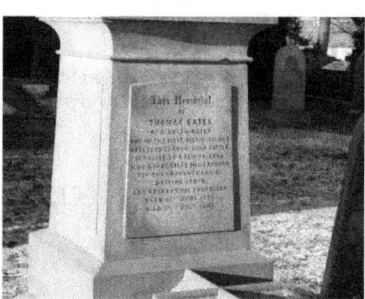

I live in the village of Kirklevington less than a mile from the house which was once Thomas Bates farm and from the churchyard where his gravestone stands. St Martin's Church at Kirklevington also has a memorial window to him which incorporates a shorthorn beast. I happen to have been born in the village of Ketton in England's smallest county of Rutland. Finally I may also be able to toast you all this Christmas in one of Yarm's many pubs less than three miles away. Which one? The Ketton Ox, of course.

Bob Scotney is a retired consultant from North Yorkshire whose articles and letters have appeared in The Lady, Ireland's Own, The Times, Best of British, ezines and local magazines.

Sepia Saturday 47 : 27 October 2010

WHAT THE CHILDREN DIDN'T KNOW

I have only been a member of Sepia Saturday for three months which is only 7% of its lifetime. So I was hesitant about re-publishing a post which was only made two months ago. But writing the post was a revelation to me as I started researching what was happening on the date which was written on the photo. This is a method I will continue to use whenever I know when a photo was taken but hopefully won't be quite as long-winded in future.

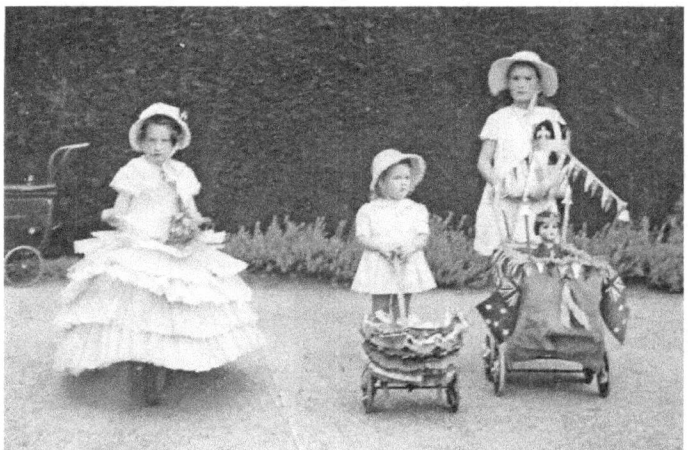

Our theme for today is groups of three. These three girls were prizewinners at Mrs Burnell's garden party.in Castlemaine, Central Victoria, on Nov 16th, 1940 . It was part of the way into World War II, when raising money for war effort charities such as the Comfort Fund, Red Cross or Bundles for Britain was the usual reason for holding a money-raising event. It was such a patriotic time, not so long after the last coronation and a new king, with the country at war. Best dresses and hats were brought out for this special occasion, and the pram reflects the feeling at the time with its crown, its Australian flags and red, white and blue bunting.. Crepe paper was the standard material for these creations, willingly constructed by parents. . And the special doll Elizabeth was named ,of course, after Princess Elizabeth.

A typical pretty, peaceful, family album picture of the time. But it is what the picture doesn't show which makes it interesting to me. When the two girls on the right got out of bed that morning they had probably been primed to wish their mother a happy birthday. It was her forty-first birthday. But they would have been blissfully unaware of the reaction of their parents when they opened their morning newspaper of choice, the Argus, from Melbourne, and its news of the war from England. .Two nights before the worst bombing raid on the city of Coventry was carried out. Over 4000 homes were destroyed and over 500 people killed. Coventry was the home of the children's 90 year old maternal great grandmother. I don't know long it was to be before the Australian family found out that she was alive and well and was to live for another two years. Then on the night of the garden party the Royal Air Force retaliated by bombing Hamburg.

But the children weren't aware of this.

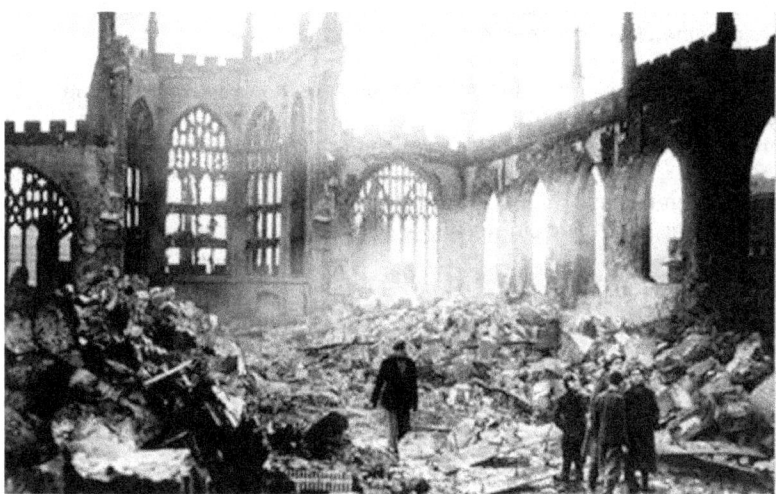

The Ruins of Coventry Cathedral

Also on the other side of the world and on that same day the Warsaw ghetto was closed to the outside world by the Nazis. In the previous month the Jewish people of Warsaw, about one third of the total population , had been rounded up by the Nazis and confined to a small are of the city, These 400,000 people were held behind three metre high walls topped with barbed wire. And on this fatal day the gap was closed. Thirty percent of the population crowded into two and a half percent of the area.

But the children in Castlemaine weren't aware of this or of a group of three children in the ghetto in Warsaw,

The garden party was held at the home of Mr and Mrs Burnell, a beautiful home with a large front lawn suitable for all the stalls and competitions that go with a fund-raising garden party. It was directly across the road from Thompson's Englineering & Pipe Works, established in 1875, where Mr Burnell was the General Manager. He had won the MC during WorldWar I. Thompson's was the most important business in Castlemaine, commonly known as Thompson's Foundry and was spread out alongside the main railway line from Melbourne to Bendigo, an ideal position for transporting the heavy goods which it made, a wide range of steam-engines, boilers, mining machinery, railway equipment and centrifugal pumps. But during World War II they made artillery and tank guns, marine engines, circulating pumps and other heavy forging and foundry work.

Making guns for war, what the children didn't know.

How's this for a crankshaft ?

The eldest girl in the photos remembers the workmen on their pushbikes, four and five abreast, sweeping up and down the Main Street on their way to and from work. With such a large work force the foundry had a piercing whistle which screamed out at 7.00am, 7.20am and 7.30am. There was no excuse for being late for work and the whole town and beyond had its own non-negotiable alarm clock.

Small towns are such a web of people and places. The mother of the two girls on the right had originally come to Castlemaine with her parents as from 1923 to 1928 her father worked in the office at Thompson's and was Bandmaster of Thompson's Foundry Band. This is the same man who brought a book on Shakespeare with him when he came to Australia. The man really did have itchy feet and jumped as bandmaster from one small country town to another several times. The Foundry has had its own brass band since 1887 and 24 members of the band served in World War I, six of whom were killed. I have no figures for the Second World War. When is the world going to learn .

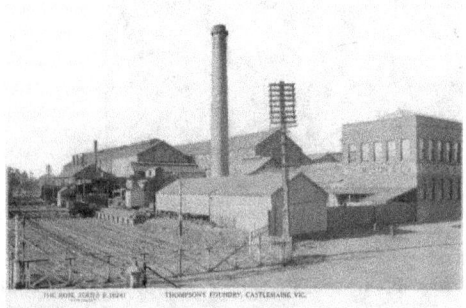 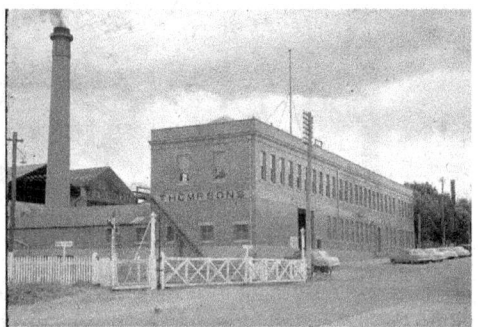

Thompson's in 1960

Boundforoz : I am an Australian woman, living in Victoria, where the majority of us are descendants of migrants.. Apart from a lengthy interest in genealogy I enjoy reading and writing, embroidery and quilting, Su Doku and TV, politics and current affairs, and anything that doesn't involve me in too much exertion. Actually I can get interested in practically anything if someone goes to enough trouble to make it interesting ! I even watched some cricket the other night.

Brett Payne : Photo-Sleuth

READY WITH THE BULLS-EYE, COME RAIN OR SHINE

A couple of weeks ago I used scans of a couple of amateur lantern slides to illustrate an article on Dovedale. This week's Sepia Saturday prompt of a rainy street scene gives me an opportunity to use a couple more from the same set, as well as featuring another recent purchase, a popular box camera which preceded the ubiquitous Brownie by almost a decade.

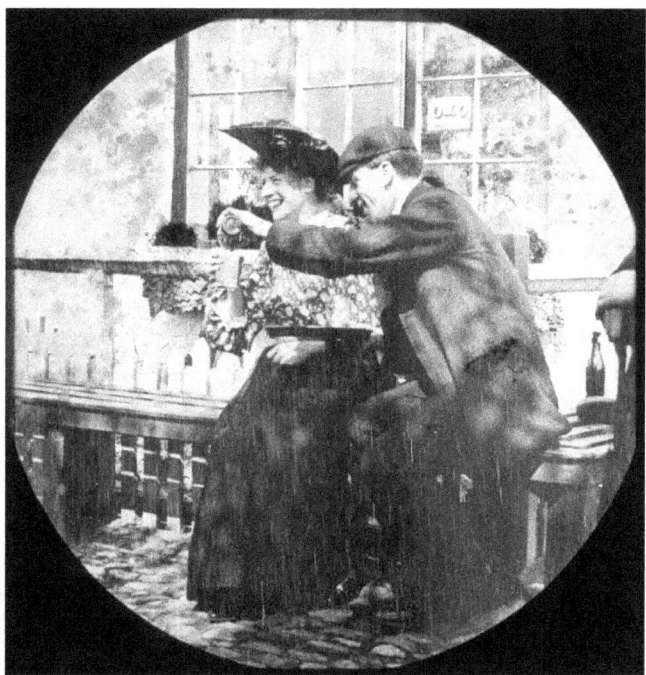

Unidentified couple seated on bench, c.1900-1905
Lantern slide (83 x 83mm) by unknown photographer

The delightful image depicts a couple enjoying what might have been a quiet glass of beer, seated on a bench outside a pub, if it hadn't started to rain. At least I think the white, nearly vertical streaks must be rain drops; after some deliberation I've decided that if they were merely scratches made during processing, they wouldn't all be roughly the same length (about 10cm). Since rain drops fall between 7 and 18 miles per hour (Source: Yahoo Answers), I estimate that this corresponds with a shutter speed of between 1/30 and 1/60 second. What has made this photograph possible is the bright, albeit slightly dappled, sunlight which accompanies the light shower of rain. The lack of self-consciousness in this candid snapshot is unusual, considering it was probably taken around 1900-1905.

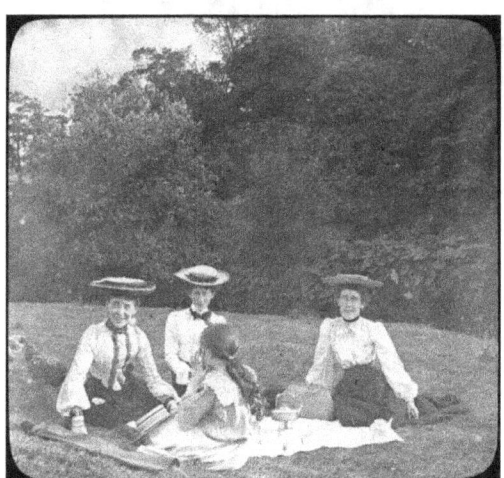

Unidentified group seated on lawn, c.1900-1905
Lantern slide (83 x 83mm) by unknown photographer

From what I've been able to tell, the very wide-brimmed and low-crowned straw hats in this second lantern slide were popular shortly after the turn of the century, which correlates well time-wise with the high-collared, wide-sleeved white blouses and long dark skirts. Here a group of three women and a young girl, the last facing away from the camera, are seated on and around a picnic blanket, placed in the middle of a well-clipped lawn surrounded by shrubs and trees. They are boiling a small kettle on a primus stove and a teapot waits patiently on the corner of the blanket. Presumably they're in a private garden, as two chickens can be seen making an appearance from the left hand edge of the picture.

The image would probably have been produced by contact printing from the original negative onto a thin glass plate, thus producing a positive transparency. Unless a portion of it was masked off - an unlikely scenario, given the composition of the shots - the original negative would therefore have been roughly the same size as the slide. The 83 x 83mm measurements of the square slides equate to the 3½" x 3½" format of 101 roll film and the short-lived 106 cartridge roll holder. The No 2 Bulls-Eye Kodak, originally manufactured by the Boston Camera Manufacturing Company in 1892, but later taken over by Kodak from 1895, was the first camera to use numbered paper-backed roll film. Both this and the

No 2 Bullet Kodak, introduced in March 1895 in competition with the Bulls-Eye, used 101 format film, as did a number of other box cameras:

Camera	Film Format	Dates of Manufacture
Boston Bull's-Eye	3½" x 3½"	1892-1895
No 2 Bullet Kodak	101	Mar 1895-1902
No 2 Bulls-Eye Kodak	101	Aug 1895-1913
No 2 Eureka	106	Jun 1897-1899
No 2 Falcon Kodak	101	Sep 1897-Dec 1899
No 2 Bullet Special Kodak	101	May 1898-Apr 1904
No 2 Bulls-Eye Special Kodak	101	1898-Apr 1904
No 2 Flexo Kodak	101	Dec 1899-Apr 1913
No 2 Plico Kodak	101	Mar 1901-1913

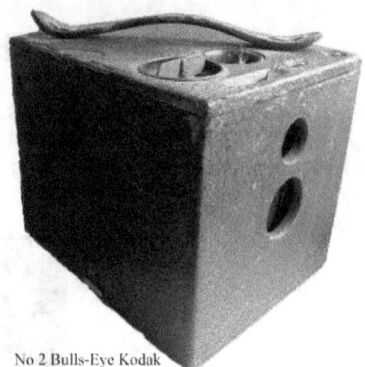

No 2 Bulls-Eye Kodak

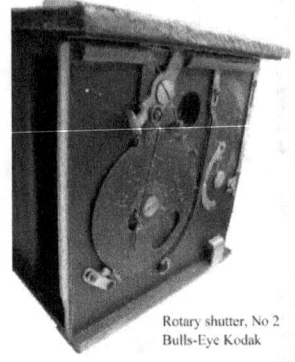

Rotary shutter, No 2 Bulls-Eye Kodak

Of all these models, the No 2 Bulls-Eye was the most successful, Coe (1988) estimating a total of roughly 257,000 to have been manufactured, and rivalled in sales during the 1890s only by its diminutive cousin the Pocket Kodak, which used the smaller 102 format film. Although I haven't found anything definitive about the rotary shutter used in the Bulls-Eye, other Kodak box cameras were manufactured with shutter speeds of 1/35 to 1/50 seconds, which corresponds well with my calculations of the exposure time using rain drop tracks.

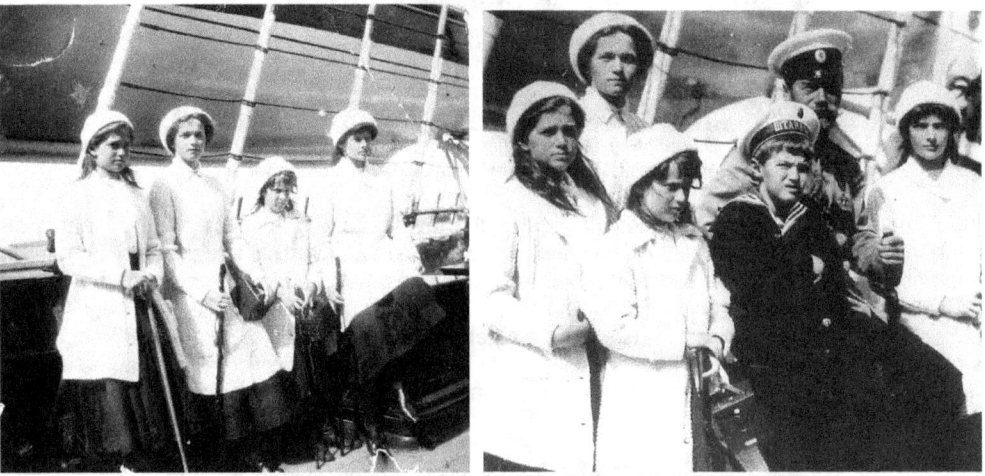

Bulls-Eye held by Grand Duchesses Olga (left) and Anastasia (right)
Taken by unknown photographer, Imperial Yacht Standart, c. 1911
Images courtesy of Royal Russia & Jos Erdkamp

Jos Erdkamp has a wonderful example of a No. 2 Bull's-Eye Kodak, complete with its original carrying case, a film cartridge, an instruction booklet, and a portrait lens attachment. He has also written an account - unfortunately in Dutch, of his detective work (Erdkamp, 1995) unearthing an intriguing fact, that the Romanov family were amongst the many enthusiastic users of the Bulls-Eye camera.

References
No. 2 Bull's-Eye Kodak (1896), on Antique Kodak Cameras from the Collection of Kodaksefke.
f/Stops and Shutter Speeds, on The Brownie Camera Page.
RUSSIAN IMPERIAL YACHTS: On Board the Imperial Yacht Standart, on Royal Russia.
Coe, Brian (1978) Cameras: From Daguerreotypes to Instant Pictures, United States: Crown Publishers.
Coe, Brian (1988) Kodak Cameras: the First Hundred Years, East Sussex, United Kingdom: Hove Foto Books, 298p.
Erdkamp, Jos (1995) De Romanov Kodaks, in Photohistorisch Tijdschrift, Issue 3 of 1995.

Brett Payne, Tauranga, New Zealand : A geologist by training, my passion is old photographs, the photographers who took them, the equipment and technologies they used, the people and scenes in the photos, and the stories behind them.

Bruno Laliberté : Ticklebear

THIS IS MY MOM

You say "200", I say "184". Same difference!! This may be my 184th post under the label "Sepia Saturday", but the hosting blog for this meme is celebrating its 200th one. We were asked to reminisce, to bring back one of our favorite posts. It was a difficult choice at first as I thought of too many things, but I came back to the basic, family, and the reason most of us have a huge or vague interest in family history, and History itself, because we need roots, apparently...

Our understanding of the past helps us shape the possibilities of the future. I present to you my mom, the only notion of family I have really as far as I am concerned. This was my very first Sepia Saturday post written on February 27th 2010. The original text makes me smile now as I never imagined back then I'd still be writing stuff under this label one hundred and eighty-four posts later... Who knew?!? Certainly not you guys as none of you knew me back then, none but one...

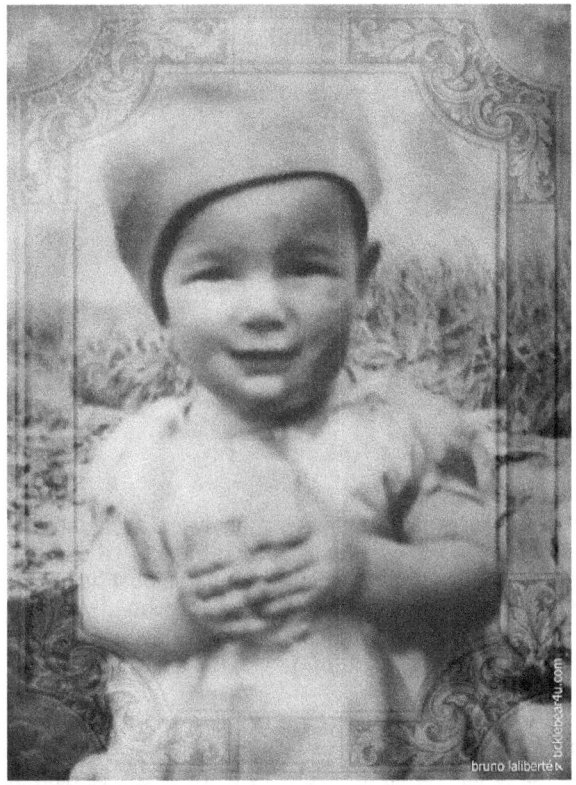

This is my mom, at a family picnic on the beach. I don't know the exact time or location, but it could be at Le Bic, Metis Beach or St-Flavie, in the lower Saint-Lawrence region, here in Quebec.

I was inspired by TONY's blog, as he's a regular with SEPIA SATURDAY, always with some funny/interesting anecdote. I don't have such, ignoring my family history and estranged from most of them, not having seen them for the last 25-30-35 years even... that's the way I was raised. Too bad!! But I've got a bunch of pictures as I've had to clean up after the only uncle I knew somewhat well who passed away at the hospital where I work. I looked after him, until his last breath, then looked after his things. I did the same for my mom. my dad is out of his home, living now at an old folks' home, but he's got all of his family albums, after I reorganized all of them. They were a mess but now are pretty to look at. The only problem is... my father is blind now.

I will not officially participate in the project, as I have very little info to provide with these pictures, if any at all. I find it somewhat embarrassing, but if you want, you can check out the official blog connecting every participant, and maybe, add your own two-cents, if you're so inclined.

I personally will carry this on here, but featuring pictures dating back to various decades, some perhaps even from the 90s, if I deem it appropriate, as I can tell only my own history... Let's just say I will be doing this very loosely. I just find it fun and interesting and a good way to prolong the life of those documents that tend to fade away with time. and a bit of nostalgia can't hurt the soul. HUGZ

And that was then and this is now!! As I said in my introduction, I never imagined carrying this on for so long. It was a fun ride for me, looking at family pictures and speculating over various details, or inventing a whole story!! And I also discussed my hometown and its history, making this very personal as I got to know Montreal a bit better myself. I've also talked about various objects I've salvaged from my parents' home, first with Alan's blessing and then on my own, I found out for example that the flag that my mom kept stored away for decades was in fact an old Canadian flag called the Red Ensign which still stands in my living room, [yes, it has survived my cats!!]; or what I thought might be a coffee pot my mom got as a wedding gift was in fact most likely my grandmother's and a chocolate pot!!! I've shown you religious medals because on my mother's side, they were devout Catholics...

Or my souvenirs from EXPO'67 here and here. I've shared what I could with you guys!! My roots are tiny and weak but you got to know me a little through all of this. As I got to know some of you as well. I cherish this little community where Sepians are generous and enthusiastic. I even managed to leave my mark on the group as the term "Sepian" was my idea: Homo Sepians, modern humans interested in genealogy and history, gatherers of information and gregarious creatures.

And I got to meet the whole tribe around my 16th post or so, and never looked back!! No idea what the future holds for me, in this world or the real one... But I am looking forward to it, one post at the time!! Congratulations

to its original conceptors, Alan and Kat, and Mister Z. obviously since he "introduced" me to you all, and Marilyn who has become a pillar of our community, and everyone else who has made this adventure even possible. Happy Celebrations Sepia Saturday!! BTW: This is obviously not the original picture. I made a larger scan and my editing skills and tools have since evolved somewhat, though that was a point of discussion at some time among Sepians, whether to leave pictures in their "original" state or using Photoshop. I've always been in favor of some editing [even if I tend to go overboard...], and those old pictures used to be new, in a pristine state once upon a time... Don't they deserve a second chance?!? Food for thoughts!! We'll have plenty of time to discuss this and many other things, I'm sure!! I hope you've enjoyed [re]visiting this Sepia post. We've learned and shared so much since the beginning. Let's keep this one of the most enjoyable experiences on the web!! Time to regroup, people!! Time to rejoin with SEPIA SATURDAY. Thanks for coming by!!

PS: I know for sure this is my mom, due to the resemblance we share at this age, I suppose it was the summer of 1931, and the location is likely St Flavie, due to the proximity to my mother's hometown, Mont-Joli, Quebec. I wonder what she'd think of my version of this picture. Would she smile, or put the scissors to it?!? No video nor music to end this, but a picture taken last summer as the Italian team [who won the competition] impressed us with a great show, just beyond MY favorite bridge!!

Bruno Laliberté, partly real, partly fictitious, a committed blogger/photographer from Montreal, by birth and by choice, an artist who worked in customer services, visual display and health care. You think this is complex, you should hear about my personal life!!!

<u>John Brindley (Caminante) : Lanzarote On Foot</u>

CAMINANTE REVISITED

Sepia Saturday is celebrating its 200th edition this week and Alan has invited all contributors to repost a favourite post . I thought I'd use this one which explains why I chose my blogging name. This post has been inspired by Sepia Saturday's photo for 13th April of a group of walkers, and my chosen blogging name Caminante, which means, simply, Walker (although it can also mean hobo!).

Photos of my childhood are rather scarce, as we didn't own a camera, so my parents paid for a photographer, usually on a birthday. This shot looks like I'm about to go for a walk, so probably is the first recording of my hobby.

We spent our honeymoon on Tenerife, during which time we went to Pico Teide, the highest mountain in Spain. Here I am right at the top. Thew air was pretty thin up there at 12,200 feet, as I realised when my cigarette only stayed alight whilst you drew on it, immediately then going out. Someone was trying to tell me something, but it took another 3 years and the arrival of our daughter before I gave up!

In 1986/7 I spent 4 months in the Falkland Islands - sensibly some years after the war! I had a weekend in January of R&R on the oddly named, but beautiful, Carcass Island, As I found, the weather there, in the height of their summer, was normally quite pleasant, although it could snow at any time. Here I am on one of the little hills dotting the island.

I've enjoyed walking all my adult life, and for the last twenty years or so, I've walked several times a month, originally around our home in Salisbury, so I've walked nearly all the footpaths in Wiltshire, Hampshire and Dorset, on my regular Sunday morning jaunts. The farthest I got (limited by the length of car journey to the start), was West Bay in Dorset, which UK readers will know as Broadchurch from the current detective series. Here's how the murder scene looked in August 2003.

Now we live on Lanzarote, 70 miles off the coast of Western Sahara, it's springtime all year round, so shorts and T shirts are all I need - and a good pair of shoes because the volcanic stone is very harsh. This photo from last November shows both aspects.

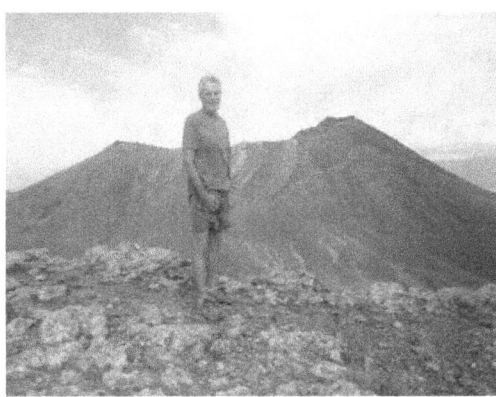

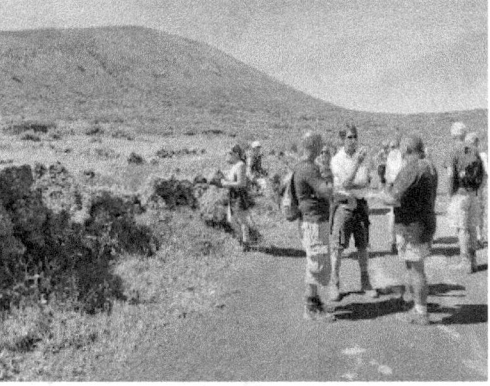

These days, I tend not to walk alone, except on well trodden paths, because, although you are unlikely to get exposure, even a twisted ankle in a spot with no mobile phone reception could be quite a challenge. I'm a member, along with about 90 others of an active walking group here. Fortunately, we normally only get between 12 and 24 on each walk, otherwise it could get out of hand! Here they are a week ago, having a breather during a walk around Los Helichos, a range of volcanoes in the north of the island, locally famous for their spring flowers.

This brings me back to the Sepia Saturday prompt, and the contrast between what is seen now and then as suitable attire for hiking. I can't imagine how uncomfortable they would have been in rain, or blazing sunshine, or indeed on anything but good paved surfaces. Perhaps it was the fact that walking was involved that was the mystery element!

Caminante : I'm a retired engineer and dedicated walker, now living in Lanzarote

Sepia Saturday 108 : 14 January 2012

Colleen G Brown Pasquale : Leaves And Branches

THINGS THAT FLOAT

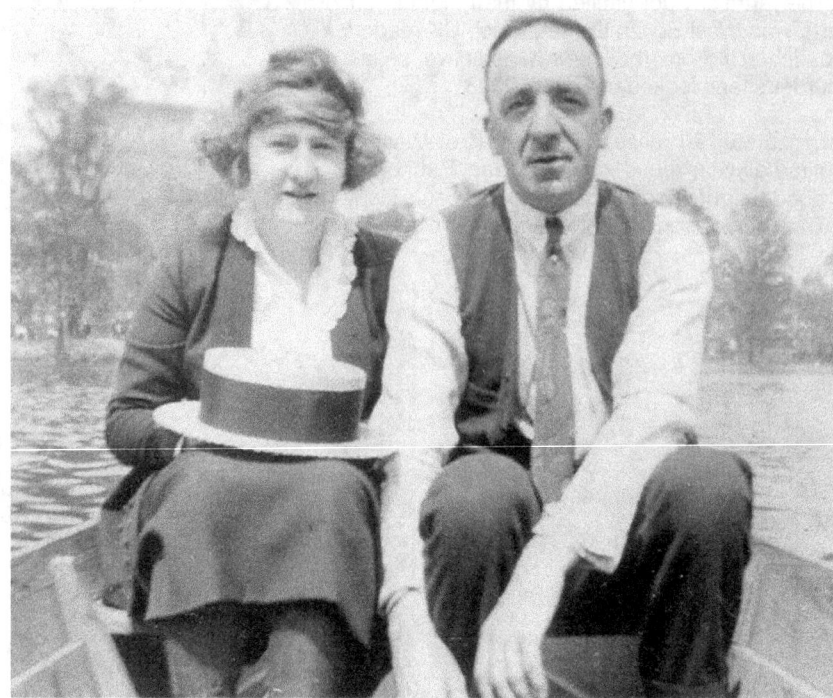

1920 Helen Coyle & Nathaniel Gardner, Central Park, NY City

This week's Sepia Saturday photograph shows a young girl in a rowboat on a lake by herself. This reminded me of the above photograph of my grandparents. They are in a rowboat in Central Park, New York City. They were still courting and not yet married. With them was Helen's youngest sister, Kathleen G Coyle, who snapped this picture.

I love this photograph. I love the way my Nana is holding the hat for her boyfriend. I love that he is wearing a tie and she is wearing a pretty blouse & skirt for their outing. Most of all, I think I love this because it looks like they are looking at me, their only grand daughter, and I wonder what they are thinking of me.

Colleen G. Brown Pasquale, a retired elementary school teacher in New York State who enjoys putting together pieces, both of quilts and family information into something everyone can enjoy.

Terri Buster : Colouring Outside The Lines

HEALTH RESORTS AND DOLLS

I've lost most of the early editions I participated in when I moved my genealogy blog to blogger from wordpress. I really liked this one the best out of all the ones I have saved:

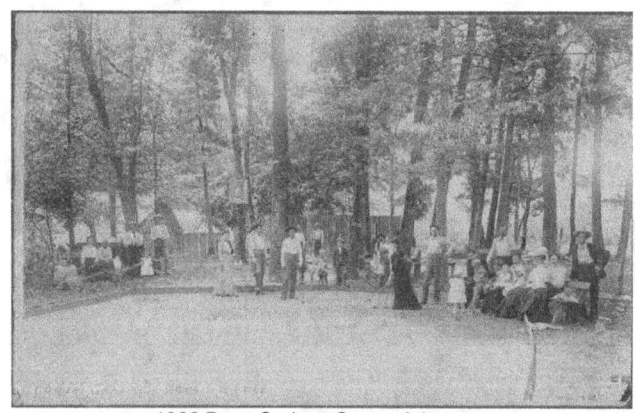

1902 Bogg Springs Camp, Arkansas
Popular health resort, located in the Ozarks. Famous for their spring water, said to heal all ills. So many neat details in this photo.

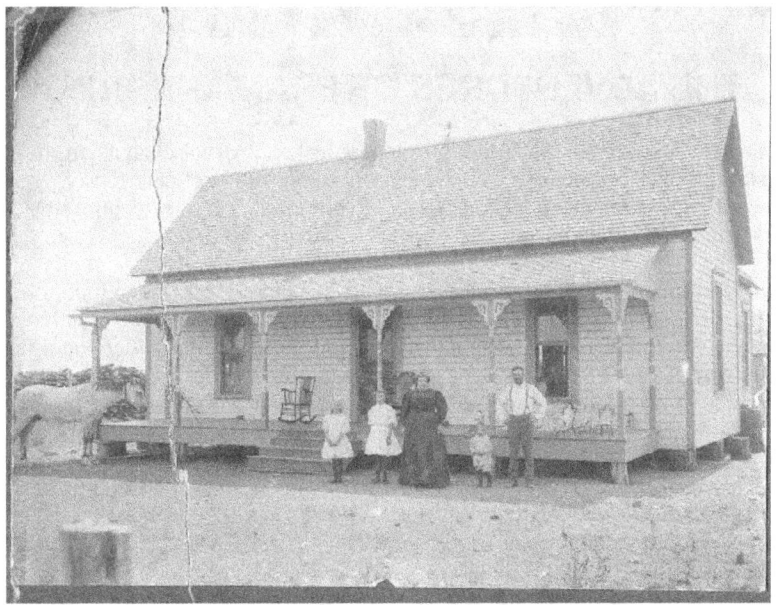

2nd Place would have to go to Dolls, Dolls, Dolls,
I think it is just adorable the way the girls have posed their dolls on the porch to be included in the photo.
And of course, the family car horse!

Dee Burris Blakley : Shaking The Family Tree

SHE MADE HATS

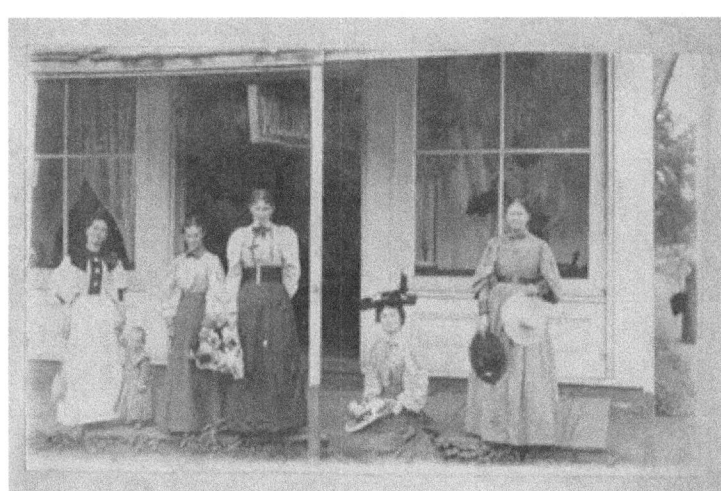

This is a photo I estimate to be circa 1868-1875 of the millinery shop owned and operated by my great-great grandmother, Mary Emily (Conner) Meek in Grenada Co., MS.

From comparing the only known photo I have of her to this one, I think grandmama was the lady seated to the right of the post.

But I can't be sure.

Dee Burris Blakley is a family historian and taphophile living in Arkansas, in the southeast United States. Since 1999, she has been pouring over the photos in the Williams family album, muttering to her great great grandmother about her failure to label them. Sometimes, her ancestors talk back. When not consumed by family history or photographing graves, Dee spends her time with three geriatric cats and a very energetic middle aged schnauzer.

Doug Peabody : Crazy As a Cool Fox

THE ADVENTURES OF FRAN AND BUNT

Congratulations to Sepia Saturday for having 200 continuous collaborative posts from a myriad of talented bloggers. To commemorate this celebratory event we have chosen to republish one of our own favorite posts contributed to Sepia Saturday over the post four years. Eventually we hope to publish a book with all of our special 200th posts. I thought long and hard about which post was my favorite...

At first my choice was perhaps a post that had the most hits or comments. Then I thought of a series of posts I offered back in 2011. I am most proud of them these posts, but ironically most of it is not my original writing. The voice is my mother's from her travel journal. My mother and aunt went on many trips together and those two gals had loads of fun. Adventurous they were! Feel free to browse the other nine posts. The links are below. This post is the first in a 10 part series on a trip that my mother and my aunt took to the western part of the United States back in 1990.

At this point in her life my mother, Fran, was recovering from complications with her legs and other health issues. She was recently retired from an admitting clerk position she held at a local hospital. Both her and my Auntie Bunt, my father's sister, were very good friends and both widows. They were also very adventurous.

This travelogue was a typical thing my mother did. She was always the chronicler of all our vacations and day trips. She kept journals for a long period of her life. I haven't even had a chance to look at those journals since she passed away. She typed these pages with all caps on my home computer (big clunkers back then) which I let her borrow for about a month.

I've divided this three week trip into 10 posts. As the photos are actual scans from the pages of her album I have transcribed the text with my own notes in parenthesis and a few punctuation corrections. I hope you enjoy and also get a chance to see this stunning scenery in the western part of the land. Let me know if my transcription is redundant. I'm not sure it's necessary.

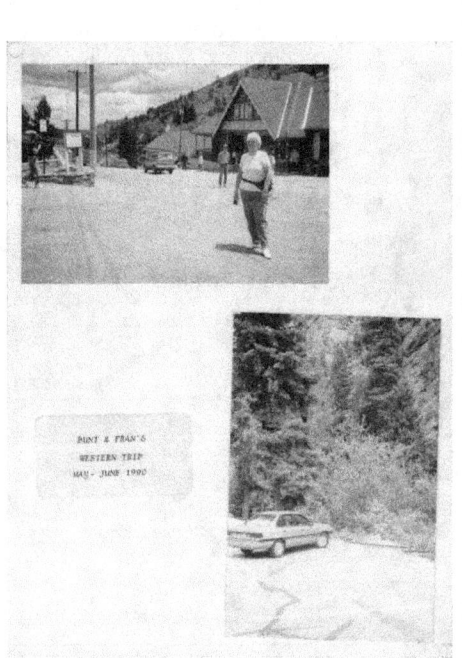 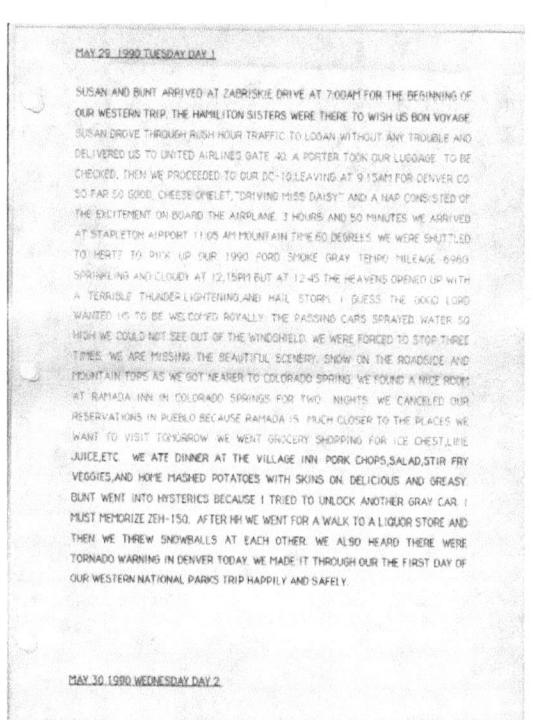

Top photo: Mom, Bottom photo: their car?

May 29 1990 Tuesday Day 1
Susan and Bunt (cousin and aunt) arrived at Zabriskie Drive (my mother's residence) at 7:00AM for the beginning of our western trip. The Hamilton sisters (good friends and neighbors of my mother) where there to wish us bon voyage. Susan drove us through rush hour traffic to Logan (airport in Boston) without any trouble and delivered us to United Airlines Gate 40. A porter took our luggage to be checked, the we proceeded to our DC-10, leaving at 9:15AM for Denver CO. So far so good. Cheese Omelet, "Driving Miss Daisy" and a nap consisted of the excitement on board the airplane. 3 hours and 15 minutes we arrived at Stapleton Airport 11:05 mountain time, 60 degrees. We were shuttled to Hertz to pick up our 19190 Ford Smoke Gray Tempo Mileage 6980. (Can you see how detailed she was?) Sprinkling and cloudy at 12;15PM but at 1:45 the heavens opened up with a terrible thunder, lightening, and hail storm. I guess the good Lord wanted us to be welcomed royally. The passing cars

sprayed water so high we could not see out of the windshield. We were forced to stop three times. We are missing the beautiful scenery. Snow on the roadside and mountain tops as we got nearer to Colorado Spring. We a nice room at the Ramada Inn in Colorado Springs for two night. We canceled out reservations in Pueblo because Ramada is much closer to the places we want to visit tomorrow. We went grocery shopping for ice chest. lime juice etc. We ate dinner at the Village Inn. Pork Chops, salad, stir fry veggies and home mashed potatoes with the skins on. Delicious and greasy. Bunt went into hysterics because I tried to unlock another gray car. (my mother was notorious for this) I must memorize. ZEH-150. After HH we went for a walk to a liquor store and then we threw snowballs. at each other. We also heard there were tornado warning in Denver today. We made it though our first day of our western national parks trip happily and safely.

May 30 1990 Wednesday Day 2

46 Degrees Sunny
We are on the road again at 7AM to Pikes Peak Cog Railroad. We had quite a long wait before the train left at 9:30AM. We talked to a nice young man who planned skiing down the north side of Pikes Peak but the last we saw of him he was hiking because the snow was not below the tree line. We were told we probably couldn't go any further than 12000 feet but the snow plow preceded us all the way to 14,110 feet. Men were still shoveling a path for us all the way into the gift shop and restaurant. We saw a marmot (looked like our woodchuck) and 3 mule deer. We met a darling 10 year old boy from Topeka, Kansas who gave us a big hug when we said goodbye. I guess he was impressed with us. Just passed a sign that said the Barr Trail 28 miles 3 hours and 27 minutes hiking the is. $17.00 well worth the beautiful trip up to Pikes. We made a shirt visit to Seven Falls for $4.00, very impressive. We drove through through the Garden of the Gods and stopped to climb on these unusual red rock formations. Spectacular setting for our lunch of left over pork chop sandwich. Back to the motel room we play rummy kubes. (they always played this game) Another great day.

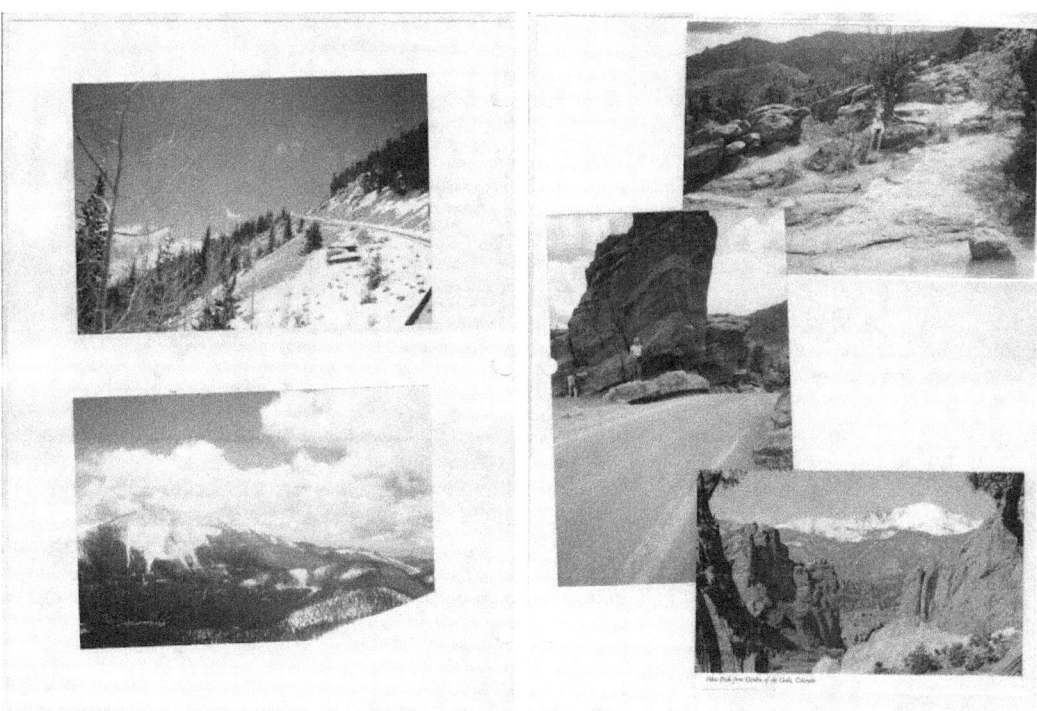

Top right photo: Auntie Bunt. Middle right photo: My mother in front of a big red rock (quite the climber)

Doug Peabody : Passionate organizer. Friendly entrepreneur. Hardcore social media enthusiast. Extreme, mainstream multisensory blogger. Bacon and TV fanatic. I am developing a business plan that will take me into the ever changing world of social media management is something consuming a great deal of my time lately. I'm highly interested in digital branding, marketing strategy, and other edgy stuff. I am self taught and self made in this new industry where I will be responsible for the social marketing of any forward thinking industries that will have me!

Helen Bauch McHargue : Guacamole Gulch

ON ITCHINESS

For the "best of Sepia Saturday" compilation celebrating the 200th post I'm re-posting number 159 - my memories of happy days spent at Grand Beach, Manitoba, Canada.

"Stop scratching." my mother said emphatically. "You're just going to make those bites worse!"

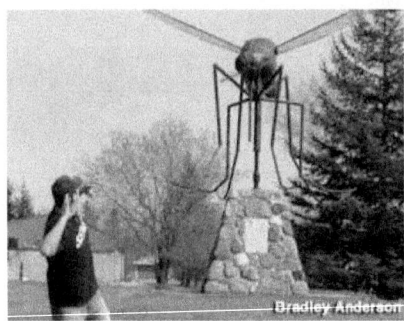

Photo from roadsideamerican.com of mosquito statue, Komarno

My itchy sister Eilleen and me exchanged looks. Mother's attention meant that serious scratching had to be reserved for after bedtime, when, hidden from her view under the covers, we could claw to our heart's content. "Eaten alive" as the saying went, we'd scratch until we bled.

Nothing in my experience is quite as itchy as a bite delivered by the legendary Manitoba mosquito at Grand Beach. Referred to sarcastically as the provincial bird of Manitoba, there's a statue erected in it's honor nearby in Komarno, Manitoba. Komarno means mosquito in Ukrainian. Mosquitoes are a serious matter up north; the chief entomologist for the city of Winnipeg is called the "Mosquito Wizard" and he's reputedly paid only slightly less than the mayor.

The only relief remedy we had in those days was a paste made of baking soda and water then slathered over the bites. I can remember the odd feeling of the paste as it dried. It was astringent and probably served to divert our attention momentarily from the itch to the puckering.

Funny when you're a kid, you just accept your surroundings as a fact of life. I actually thought it was fun to sit on our stoop, counting the scabbed-over bites on my legs! Who knew there were places in the world where you could actually walk around in the summer and not be swarmed by mosquitoes? For me, the torture of itching and the joys of warm weather went together hand in hand.

While mosquitoes were the worst of the lot, there was plenty more entomological fun to be had with the sticky-footed fishflies we pulled off the telephone poles and screen doors; and the annual invasion of dragonflies which fed off the fishflies.

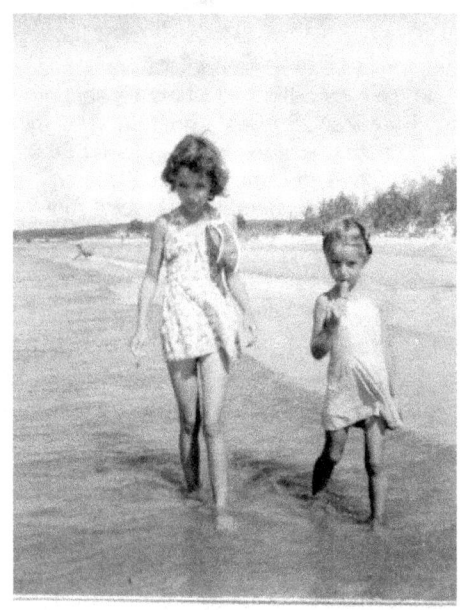

This photo of my sister and me, circa 1948 at Grand Beach, Manitoba, Canada, shows us strolling merrily along the shore. Eilleen has her red bathing cap fastened to her swimming suit strap. We were blissfully without sunglasses, sun screen, water wings, insect repellent or too much adult supervision, happily ignorant of the risks of such an unprotected stroll. We even had a break from the daily agony of the Cod Liver Oil dose, the idea being that we were storing up sufficient Vitamin D with all the sunshine. Mom, throwing caution to the wind, let us skip "Beef, Iron and Wine" the other foul tasting dietary supplement we were forced to take because we were too skinny.

Just the girls, we spent two glorious weeks at the rented Walt's cottage. My father stayed in the city and took the "Daddy train" up on the weekends. With no Dad around, proper meals weren't necessary and Mom made our food into terrific fun: fried eggs for dinner; spam sandwiches sitting on the rocks lakeside; toast cooked on the wood stove and exotica such as Kraft Macaroni and Cheese dinner, which remained a special treat of my sisters for her entire life. Even bedtime was fun as mother made us go to sleep when the lamp lighter came around with his tall ladder to light the coal oil street lamps. We loved to watch this and sat by the window waiting for his arrival. Once the inside lights went out, our serious scratching started. In the background, always, there were mosquitoes buzzing.

Normal routine was forgotten on these holidays as we spent hours paddling around in the water, building sand castles, playing with a beach ball and burying anyone who would allow us the honor. At lunch we'd sometimes get chips in a paper bag, soaked with vinegar and liberally dosed with salt. No one cared about greasy fingers or faces - we'd run into the water (no two hour wait) and splash it all off.

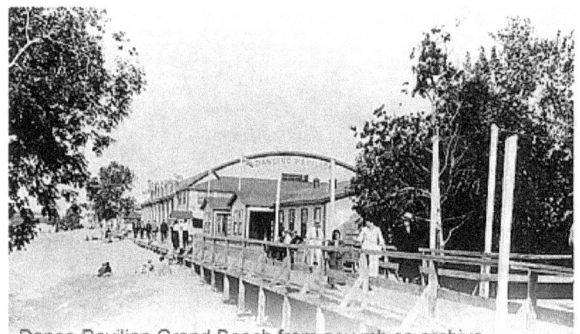
Dance Pavilion Grand Beach from gov.mb.ca archive

There was a famous dance pavilion on the boardwalk, the anchor attraction at the beach; some claim it was the largest dance hall in the commonwealth at one time. I have vague memories of going there in the evening with my Mom and sister on those endless northern summer evenings, the light in June lasting until 10 pm. Mother would dance in the cavernous hall with anybody who asked - I'm sure she enjoyed the male attention and it was all part of the vacation from her normal life. Burned to the ground in 1950, it was never re-built and the beach was never quite the same.

I was deliriously happy on those holidays, maybe as happy as I've ever been. The resort was built by the railway and there was excellent train service all summer. I would have been 5 or so in my first memory of going to the train station. My sister and I held hands tightly, shadowing my mother who was preoccupied with the business of our suitcase and the tickets. In those days we didn't own a car and world exploration was limited to the single block up and down our street. As you can imagine that first train trip was unbelievably exciting, full of new and different experiences. Between the swaying cars, we watched the train tracks speeding by underneath; drank out of triangular folding paper cups from a spigot in the wall; lurched along the aisles peering at the other passengers; nestled into the plush seats and watched the scenery rushing by. Of all my travels since, those one-hour rides may have been the most thrilling of all, infecting me forever with the travel bug.

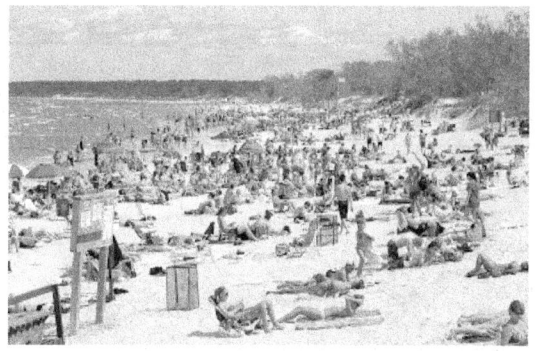
Grand Beach today (same view as the photo of the girls above)

Some itches are easier to scratch than others. After college, I moved out of the insect cloud to mosquito-free California. No more sitting around counting bites! Now my metaphorical "itchy"footed condition is the one I've dedicated my lifetime trying to alleviate. The only temporary relief I've found so far is the sound of those beautiful words, music to my ears, "Let's Go!".

Helen Bauch McHargue retired from the food consulting business, Food Smarts and now lives on an avocado grove in Fallbrook, California with her husband and two cats. She enjoys traveling, eating well, reading and writing about anything that interests her.

Howard Webb : Postcards Then And Now

LONDON BRIDGE, CITY OF LONDON, EARLY 20th CENTURY

London Bridge joins the City of London on the north bank to the city of Southwark on the south bank. The London Bridge that you see in these old postcards is the 19th century bridge, designed by John Rennie and built next to the ancient London Bridge and opened in 1831. The ancient bridge was then demolished. At the time of these postcards it was the busiest part of London. It is still very busy today, but the modern Google Street Views make it look relatively quiet. I can assure you it is not. By 1967 this bridge was inadequate for the job and was sold. It now resides in Lake Havasu City, Arizona. A modern replacement for London Bridge was opened in 1973. In the first postcard you can see the view from King William Street looking south towards the bridge and Southwark. The statue is of King William IV and is now in Greenwich. The first postcard is a particularly good one, published by A & G Taylor, so I've scanned it at 300dpi. The rest are at my standard 200dpi.

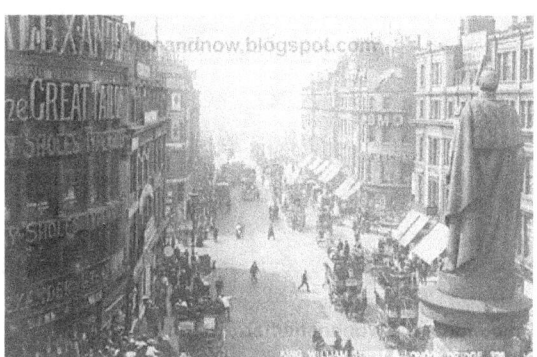
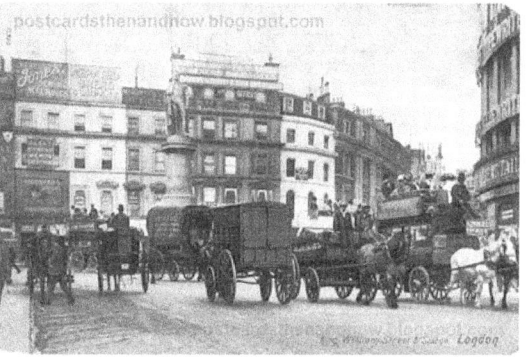

In the second postcard we can see the location where the first postcard was photographed from. Below left, a view of traffic on the bridge from the south bank. In the distance on the right you can see the Tower of London:

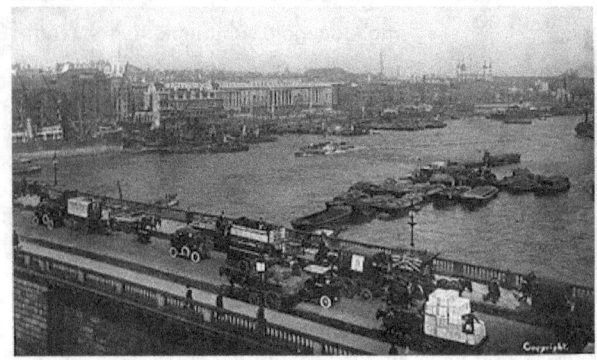 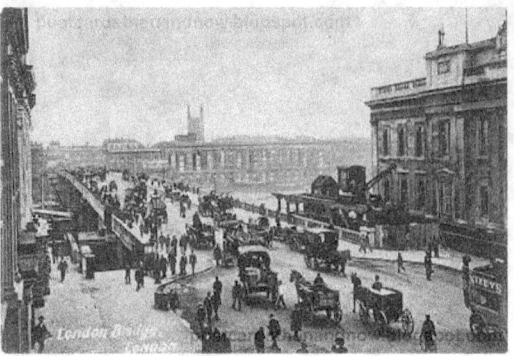

Above right, a view from the City of London looking south towards Southwark. The church you can see is actually Southwark Cathedral. The building on the far right is Fishmongers Hall. Below left, a view looking north, you can see a paddle steamer on the far bank. The church you can see is the tower of St. Magnus the Martyr. To the right of that is the Monument, one of London's most famous landmarks. Below right, a view from the Monument looking south. you can clearly see the tower of St. Magnus the Martyr right in front of you and Southwark Cathedral across the river. This picture looks like it may have been taken before the bridge was widened in 1902.

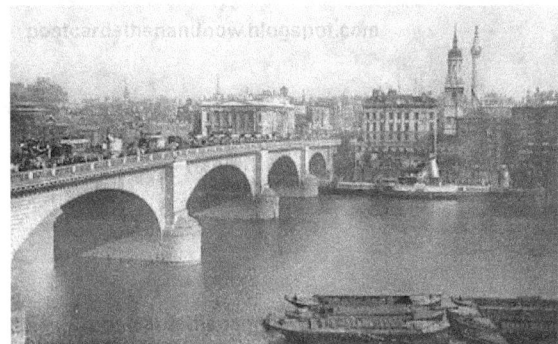 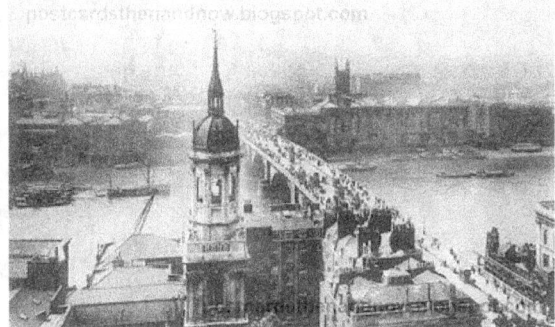

Finally, another view from the Southwark side looking north towards the City of London:

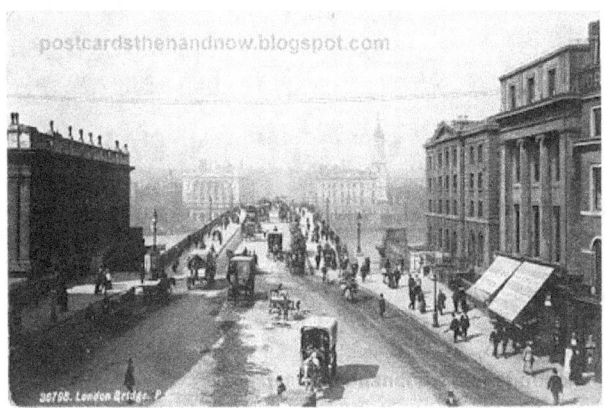

Howard is a collector and dealer in vintage postcards and printed material who lives in London.

Jennifer Geraghty-Gorman (Irisheyesjennifer) : On A Flesh And Blood Foundation

THE SEA OF LOVE

In honour of this landmark occasion, we have been asked to choose the favourite among our personal posts and repost it. Without a doubt my favourite Sepia Saturday post is #167. The two older images in this post hold a very special place in my heart because they show my mother and my father when they were first courting. Back then, before marriage, children and work responsibilities became the principle occupations of life, they seemed to have not a care in the world.

Both of my parents are gone now — Dad in 2000 and Mom just last year — and they are both very much missed, so it means a lot to me to be able to gaze into these photos from their past, and see Mom and Dad when they still had their whole lives ahead of them.

At the bottom of the original post I have added a recent image of Ireland's Eye. These days the sailboats outnumber the rowboats, and the place is teeming with people on the weekend. Still in all, it is nice to see so many couples and young families out together creating their own memories.

So...Come with me to the Sea of Love...

For some reason when I was looking at the photograph Alan posted as inspiration for Sepia Saturday #167, Robert Plant's version of 'Sea of Love' started running through my mind. The song is a very old one, an R&B standard from the 1950s, but the version which plays in my head is from the long hot summer of 1984. No matter what the time period, or the version, the lyrics remain the same:

> Come with me, my love,
> to the sea, the sea of love.
> I want to tell you just how much I love you.

This song, and the inspiration photograph, got me thinking about images which feature family members, and boats in water. In particular I was reminded of something Mom told me about the days when Dad was courting her. Of course, back then they were just Mike and Mary.

One of the things Mary loved best was travelling by train with her beau Mike to Howth, North County Dublin, for day trips during the summertimes of their courting years. Once there, Mike would hire a row boat and take his girl Mary out to Ireland's Eye. They would always bring a picnic and spend the better part of the day there. It must have been great fun, and very romantic too, given the sparkle in Mom's eyes anytime she recounted these adventures on the 'sea of love'. Sometimes it was just the two of them, and sometimes they would travel with another couple or a whole group of friends. It's lovely to see these images, and the joy on their faces in those halcyon days.

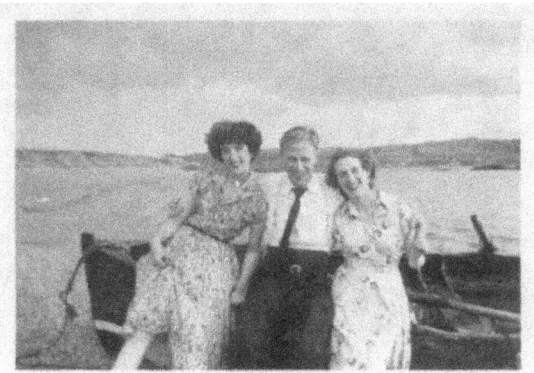

Mike and Mary on the right hand side of the photo, with an unidentified friend on the left who is being cheeky and showing a bit of knee. All three are leaning on one of those row boats. Taken in the summer of 1950, Mike was almost 21 and Mary was 19.

Mom and her friends atop Ireland's Eye. Dad took the photo.

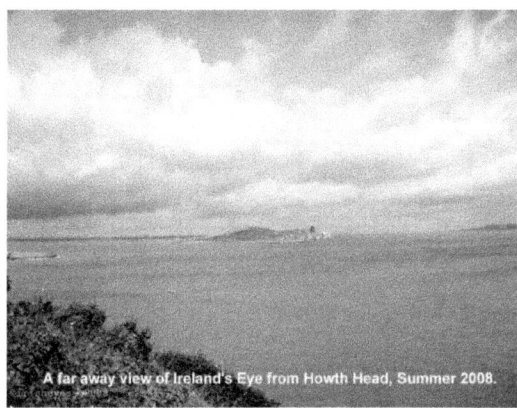

A far away view of Ireland's Eye from Howth Head, Summer 2008.

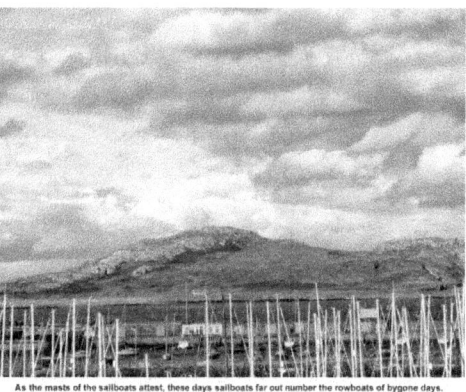

As the masts of the sailboats attest, these days sailboats far out number the rowboats of bygone days. Ireland's Eye from Howth, Autumn 2013.

Jennifer Geraghty-Gorman (irisheyesjennifer) is a Canadian born member of an Irish family whose Blog – On A Flesh And Blood Foundation : An Irish History – tells the story of the search for her family across time.

Jackie McGuinness : Junkboat Travels

GLOVES, BONNETS AND PENETRATING GAZES

I first posted to Sepia Saturday in January 2013 and this is my 37th post. It has been a lot of fun and some challenges when trying to match the weekly themes. I love doing this weekly and it has given me the momentum to do some serious investigation into our family roots. The exercise this week is to re-post your favourite post. For me that would be the one where I did a lot of homework investigating the Irish census of 1901 and 1911 to discover fascinating information about my maternal side of the family.

UPDATE: I have since added some additional information that I have uncovered using the 1908 and 1949-40 Dublin electoral lists.

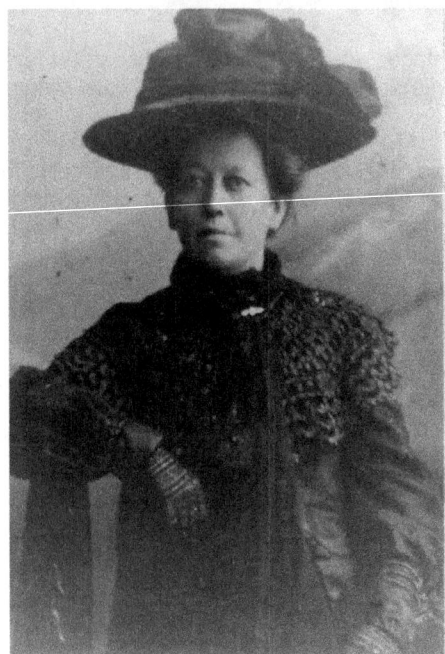

I'm going with gloves, bonnets and penetrating gazes this week. This is Mary O'Reilly Halpin, my great-great grandmother. In the 1901 Dublin census she was 39 years old and her daughter Catherine would become my great-grandmother. In 1901 Catherine was 18 years old and a general domestic servant, I wonder who she worked for???

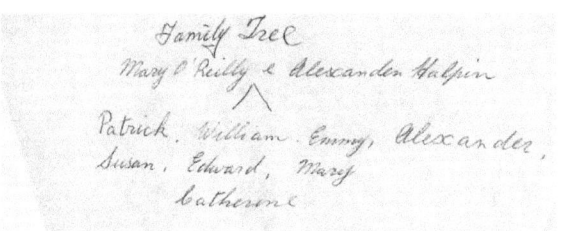

Mom's handwriting confirming the names above. William is not on the census so he must have left home by 1901. It also appears that my great-great-great grandmother, Hanora O'Reilly lived with them. And I now know that she came from County Kildare and was born in 1829.

In 1908 Alexander Halpin is registered on the electoral list still living at Belview. However, there is no record of his wife, Mary on the electoral rolls (the Mary listed above him is at a different address).

My great grandparents must have married around 1904-5 as my grandmother was born in 1906 (confirmed on her grave stone). On the electoral rolls in 1908 there is a William Brennan living at 191 Phibsborough Rd. but I could only find a Kate (Catherine??) at 91 Phibsborough Rd. Kate was a common nickname in our family. Could this be an error in the address?

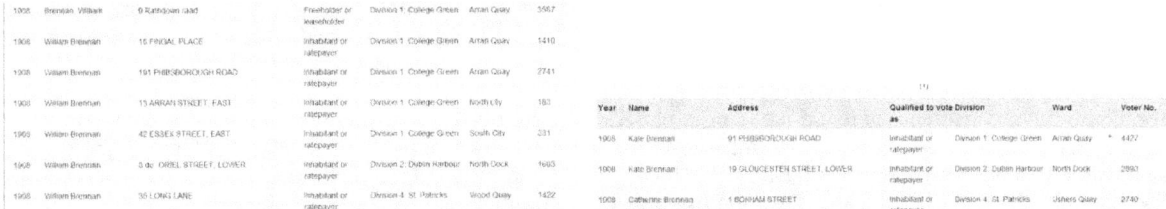

However, in 1911 William is on the census and Catherine isn't as she had married William Brennan by then and my grand-mother and grand-uncle had been born. Mary V is my grand-mother but she always went by the name Veronica or Vonnie.

Monica in 1911 was listed as Mary in 1901, I think this is a mistake as I am not aware of any Monicas in our family. Emily and Susan had jobs as a cigarette maker and a printer. I remember visiting these two great-aunts in 1970. I'm not sure if they ever married. The address changes in spelling between 1901 and 1911 Bellevue and Belview. My great grandfather's memorial card states Belview.

Using the 1939-40 electoral lists I found my grandparents Vonnie and Tommy married and living at 22 Brown St. in the Coombes. I remember my mother talking about being born in the Coombes and going to a Brown St. school but not the actual name. In 1939-40 my mother would have been 10 years old.

22 Brown St. doesn't appear to exist anymore.

Jackie McGuinness : My blog is mainly about our passion for travel with some soap boxing thrown in. There's also my favourite recipes and lots of other stuff that I enjoy. I also have a passion for photography, digital scrapbooking, crafts, gardening and reading. I live in Toronto, was raised in Montreal and was born in Dublin, Ireland where we frequently visit.

Jackie van Bergen : Jax Trax

A FAMILY OF PICNICS

This week is the 200th 'birthday' of Sepia Saturday – a great achievement. I have only been participating this year, and not every week. To celebrate we revisiting our Sepia Saturday posts and choosing a favourite one to republish.

The post I have chosen is my response to prompt # 190 (17 Aug 2013) and was one of my most commented on posts. This post represents some of the main reasons I am writing a blog – I have so many old family photos and by posting them it prompts Mum and Dad to tell their stories (and produce more photos).
For example, they recently tracked down the exact place where the first photo was taken!

A Family of Picnics

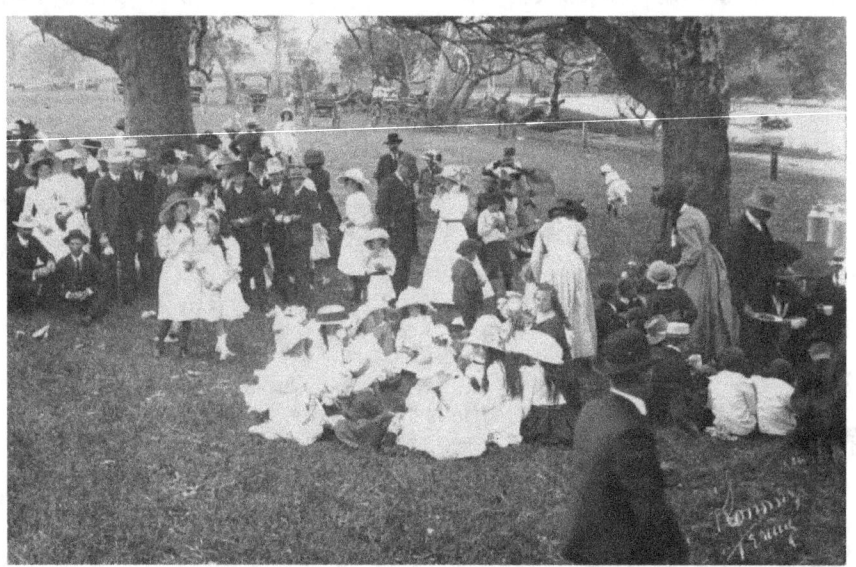

Sunday School Picnic at Terang c1910 : My Uncle Bill (8-year-old) is just right of centre with a handful of cherries on his way to his mother, my great grandmother

I have so many photos to go with this prompt I hardly knew where to start. We are a family of picnickers over many generations. Australia certainly has the weather for picnics, and the space. I guess many families have picnics but ours not only photographed themselves on picnics, leaving the evidence many times over, but they also kept the photos for generations and generations. This week's photo prompt, as usual was accompanied by some 'word' prompts:
- picnics (check),
- kettle (does a billy count?),
- primus stoves (does a campfire count?),
- teapots (again the billy but I think I have a silver teapot),
- chickens (well they always ran around in our backyard / farm – just too fast for the photos, but I'm sure we ate chicken),
- gardens (Australia's 'big backyard' was our garden, but here is one of my Nanna in her garden),
- straw hats (and white hats and bowler hats and more at the Terang Sunday School picnic),
- blankets (also plentiful),
- shy girl (that'd be my mum)

So here's way less than half the picnic shots I have:

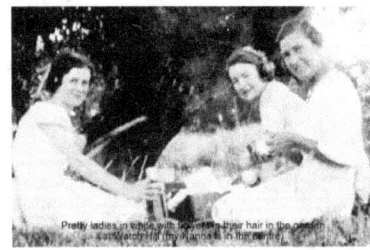 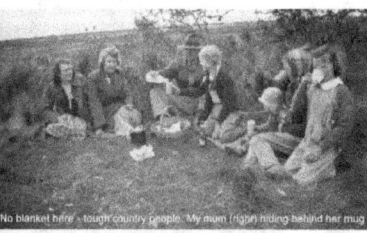 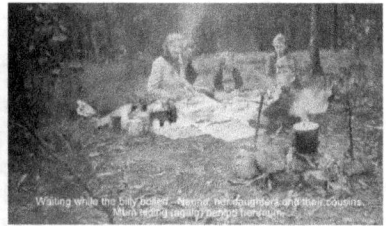

I love the happiness in this photo! My Nanna is centre back.
My grandfather's brother (Uncle Ricky - see Anzac Day blog) is at back.

And a couple of extra photos for good measure:

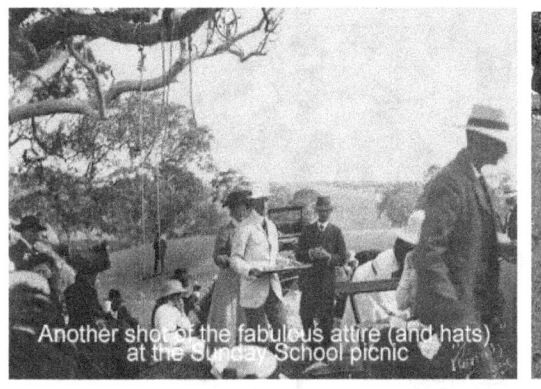
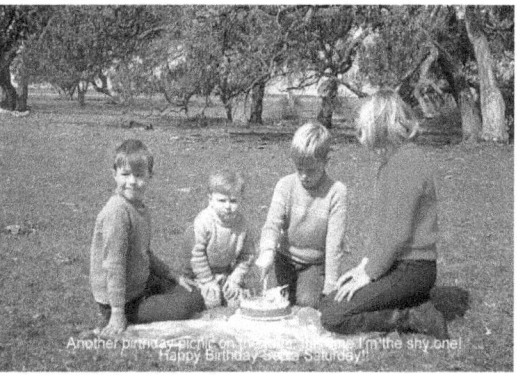

Jackie from Jax Trax is Jackie van Bergen, a family historian lucky enough to take up the habit while her parents and even grandparents were alive. I joined Sepia Saturday when a visit to my parents unearthed an enormous collection of old family photos dating back to even their great grandparents! My part time proof reading business helps fund my passion. Originally from country Victoria I now live in Sydney with my husband and step daughter.

John Foster : Loghead

SOMETHING A LITTLE DIFFERENT

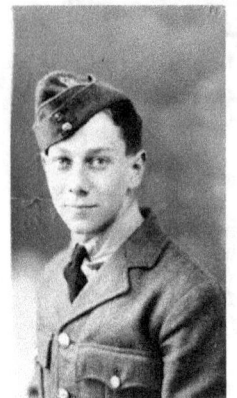

About a six months or so before my dad had his stroke, he and I started looking into his war record with the RAF during WWII. We had a lot of fun doing it. His time in service was always something special to him and he had great memories about his time served. He had his war record book, but his memory wasn't good enough or enough time had passed where all the abbreviations no longer were clear to him. Luckily, while doing research into his squadron's we found someone in Belgium that was keeping a site for one of his old units, 350 Squadron.

With his help, and another Englishman's, we were able to fill in most of the details. We sent to Belgium (not hard with email) a photo we had of dad in uniform, and a nice piece about dad was added, along with the picture, to the 350 web site.
Here is the picture.

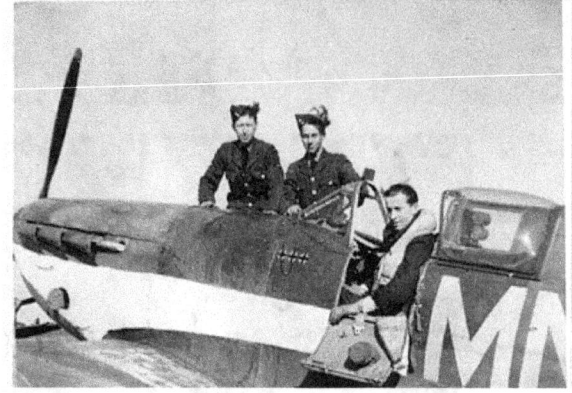

The 350 web site has in its gallery lots of photos of the unit, but most are of the Belgium flyers and crew. Well, once we got all dads info set up, emails back and forth with a little Bio. on dad, the web master thought I would be interested in a DVD of all the pictures he had for the unit. I said sure, I would love it. I wasn't expecting much, and thought we had all the pictures we would ever see of dad in uniform. When the DVD arrived, I popped it in. Low and behold (do they say that anymore?) the second picture to come up was this one. . . .The crew member on the wing on the right sure looked like dad!

I showed the picture to mom and brother, because there were no names of the ground crew on it. And both agreed it must be dad. The markings on the plane were for an exercise that took place during the time dad would have been with the 350. We were able to find out the name of the pilot, but not the other crew member. Dad always loved the Spitfire, even still has a tool for working on them in his workshop. He was with the unit for about 18 months, even working with some of the Eagle Squadron on occasion.

John Foster : Kayaker, artist, Sherlockian, history explorer, log cabin builder, dad.

Karen Sather : 21 Wits, By Karen

HAPPY BY THE NATURE OF THEIR SMILE

Sometimes, all you need, is to know someone by their smile! By way of "photo introduction" please welcome a few unknown subjects.

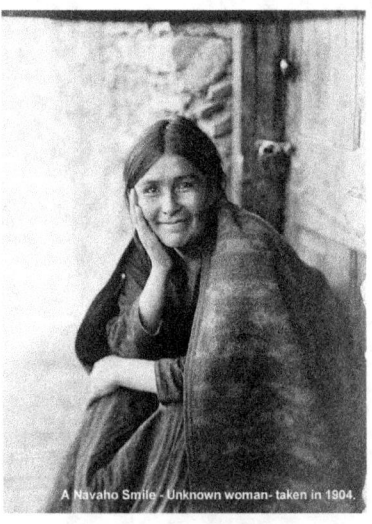
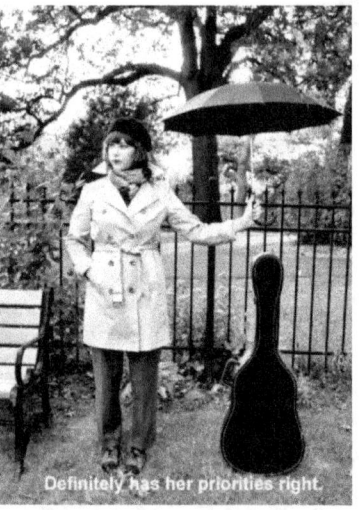

A Navaho Smile - Unknown woman - taken in 1904.

Definitely has her priorities right.

Have you guessed that we're stepping off into the unknown? As in photos of unknown people, families or places. Of course, what is unknown to one party might perhaps by chance, be someone that you might recognize.

LET THE UNKNOWNS TAKE STAGE

What can be said about these unknown people, is that often times who they are or possibly what they are doing is caught forever in a photograph. Let's peek into their lives.

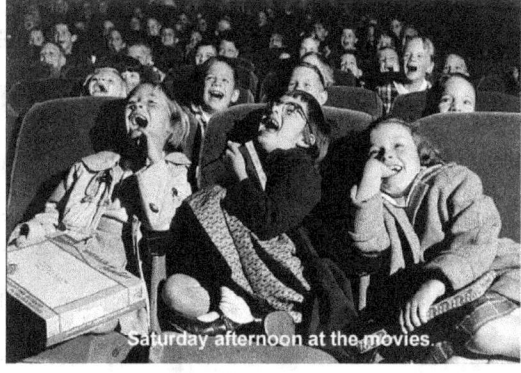

LIFE IS SO GOOD!
All we know for sure- she's either running from the girdle store, and rather happily pleased by her selections, or the girdle store just happens to be there, and the love of her life is chasing her!

I prefer the latter!

FAMILIES

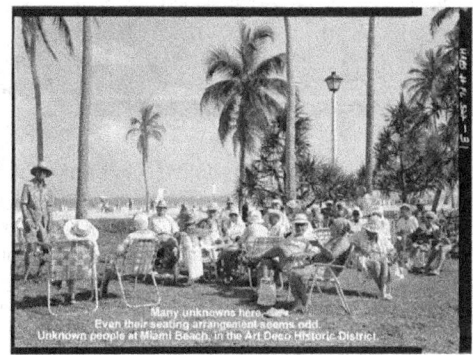

Unknown men agreed to having their picture taken in February 1939 some place in Texas. The large heading on his newspaper is advertising a furniture and rug sale. But their story seems to be so much more in this one simple shot. Notice the child running by a trailer?

FACES, isn't that really enough? It's certainly still a quest of photographers today. These and other photos share where someone was, and for one brief moment seized their stage.

The Lost Persons Area as the sign reads, is a good place to end my post for unknowns. So, may all the unknowns and lost people find their way back home again!

Have you guessed that my most favorite part of a photo, is the story that flows through my thoughts of it? I bet it's the same for you too!

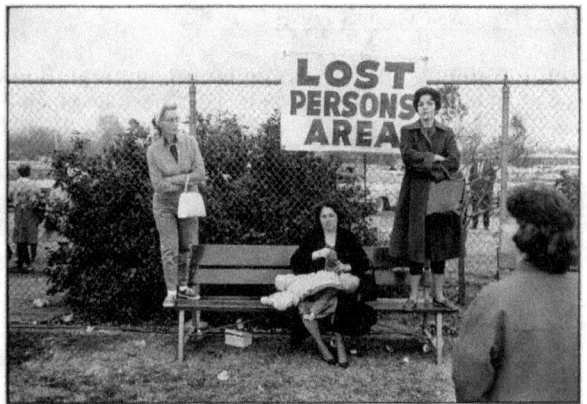

Karen Sather, Minneapolis, Minnesota, a lifelong researcher, writer and dreamer. Living with an irresistible need to uncover my ancestor's stories but also, to unearth architectural and historical discoveries, as well.

Kat Mortensen : Acadianeire's Heritage

KATIE REVISITED

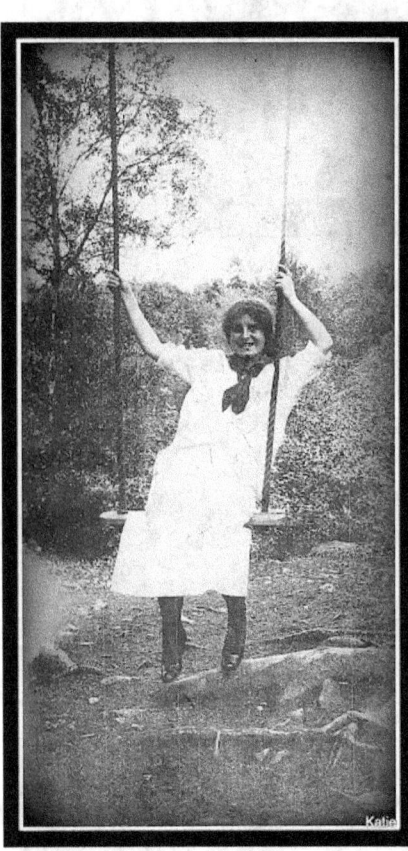

She was 18 when this photograph was taken. Home from Mount St. Vincent University in Halifax, Nova Scotia, she shed the young lady who was studying hard to make a career for herself as a teacher to indulge the little girl that was still there in her heart.

You can see how much she's enjoying herself by the big smile on her face and the relaxed posture—the slight lean of her body. Note, how she loosely grips the ropes, how her arms hang almost slack and her feet dangle in their shiny black shoes and dark socks.

She was born in 1896 and died in 1990 at the age of 94.

In December, 1902, she got to sit on Marconi's knee when he was in town to make the first transmission of a radio message to cross the Atlantic. Her father was the town clerk of Glace Bay and brought his six-year old daughter to see the event. (I wonder if a newspaper clipping exists somewhere?)

She was a life-long fan of Prime Minister Pierre Trudeau and there was even a rumour that she had a rose he had given to her personally on one of his campaigns.

She loved to watch the Montreal Canadiens trounce the Toronto Maple Leafs in ice hockey. She wouldn't say no to a drink of beer on a hot summer's day. Her only regrets in life were that she never learned to use a typewriter or drive a car.

She was my grandmother, Sarah Katherine "Katie" Harris (nee McNeil).

Addendum: I have just recalled this book that I came across in my mother's possessions which belonged to my grandmother. It has an inscription in her handwriting on the flyleaf inside. The book was from one of her classes at "The Mount" and is entitled, "Speech On Conciliation with America" by Burke. Sounds pretty dry to me, and it must have been to her as well, for the inscription (after her name and address) is anything but:

Katherine McNeil Mount St. Vincent Halifax 1914-1915 Nova Scotia

The Ivy - - - Hope
Although we part with tears and pain
From those who hold our love
We know we'll find them all again
In the fields of light above.

A bit of research tells me this is probably a misquote of the Henry Wadsworth Longfellow poem, "The Reaper and the Flowers". This is the original verse:

> "And the mother gave, in tears and pain,
> The flowers she most did love;
> She knew she should find them all again
> In the fields of light above."

I like who my grandmother must have been.

Kat Mortensen : If you know me, you know I'm a homebody, an introvert, a fanatic about words, animals and footy. I am a faithful Catholic. There is not a minute of the day where I'm not thinking about food. I kid you not. Luckily, I have a very high metabolic rate.

Kathy Matthews : Oregon Gifts Of Comfort And Joy

THE WAR LETTERS

Sepia Saturday is 200 weeks old today. I have enjoyed participating in this meme, and interacting with the wonderful group of friends that I have met over the past several years. It seems that I joined up with Sepia Saturday sometime around March 2011. Sadly, I have been inactive on my blog, mainly because I began working full-time in March. (FB is so much easier, though it isn't the same as blogging at all.) I miss you guys a lot!

I had so many options to choose from as I searched through my old posts. I wanted something that would be interesting to others and also meaningful to my Mom and to me. I decided on this one, originally posted on February 7, 2012:

The War Letters: Uncle John Visits a Cemetery in Natal, Brazil

This is a War Letters post. The War Letters are a manuscript compiled and typed by my cousin Lyle Hedrick. Lyle was my Great Uncle Hobert Hedrick and Great Aunt Flora Fletcher Hedrick's boy, and Danny Hedrick's brother. In the following letter, my Great Uncle John Hedrick (Hobert's younger half-brother) was stationed in Natal, Brazil in World War II. Uncle John wrote this letter to his sister-in-law, Flora.

I find the content of this letter very fascinating indeed. Leave it to a Hedrick or a Letsom (ancestors on my Mom's side) to find it great fun to visit a local cemetery in Natal, Brazil in their free time!

Right : Hobart and Flora Hedrick with baby Danny and Flora's Dad, E.B. Fletcher in 1925

(By-the-way, the AACS stands for the Army Airways Communications System, and that was Uncle John's job while in Brazil.)

> (834)
>
> (1)
>
> Sgt. John L. Hedrick 39308997
> 74th AACS Group
> APO 604, C/O Postmaster,
> Miami, Florida
> Natal, Brazil
> 21 April, 1945
>
> Dear Flora:
>
> To start this off I must put you straight on a few little items, the first being my I.Q. which isn't so hot. The only reason I got into this outfit was because they didn't know what else to do with me. I had a choice of radar, gunnery, communications cadet and A.A.C.S. Of radar, I thought I had had enough of the electronic theory; gunnery meant flying and you may say what you like, but I'm skared spitless of them flyin' machines, and especially so when they are making a power dive at 5000 feet and being past middle age, I was beat before I got started. On com. cadet I believe 26 was the age limit, so that was that. So you see there was only one thing left, A.A.C.S.
>
> Now that I have explained why and how I'm here I hope you are convinced I'm not trying to sell you the idea I'm so smart for you know as well as I, it "ain't" the truth. Truthfully, I was only trying to give you an idea of what we are. I mean what they are. Count me out.
>
> I'm glad Lyle got home. From the tone of your letter he must have had a good time both at Drain and Portland. I hope Dan has had a furlough by now. As for me, I'm wastin' out mine. Hope and seriously expect to get home sometime this year.
>
> My 2 years will be completed in July. So I'm planning on making my trip to Stateside around the 1st of Sept.
>
> Halverson has moved on to another station in this region. I miss him as we used to hit the P.X. together for a Coke and then make the Mess Hall. We were always comparing notes and talking of God's country.
>
> And the chow!!! Let me tell you--golly what a mess! Stewed liver!!XTX. When liver is so bad it must be boiled or mixed up with a lot of alum gullion, something must be wrong. As for me, I can't choke down the best calf liver that ever came out of a Durham, but stewed! whew!
>
> (1) continued

> (835)
>
> (2)
>
> (letter from John Hedrick, 21 April, 1945 Natal) cont.
>
> Then one nite we had steak and I thought it was fried liver so passed it by. That was the main item on the menu that nite so there I was with nothing to eat. Pride wouldn't let me go back and get some, because as I went thru the line, the cook practically climbed over the table trying to throw it on my tray, and I was maneuvering my tray fast to keep from getting it, that the meat finally fell on the floor. Then when I got to my table and saw what I passed by, naturally I couldn't go back. Finished eating by drinking a couple cups of water and eating some bananas. Taken together, they're really filling, and believe me, there is plenty of food in a banana. They (the bananas) have saved me from starvation many times.
>
> And now we come to this purse deal. Purse indeed! Just who and what does she think she is? Some goddess, with wings on her shoulders and a halo around that beautiful head? I may be simple but not that bad. You may tell her for me I'm not interested. I'm just going to be "plain hard to get," and besides, I have about decided to continue as I have in the past; eligible, but not susceptible, that's me.
>
> You know I have a very guilty feeling about not writing that letter you asked me to. I'm sorry. I have been a bad boy. Remind me to have you kick me next time I'm around.
>
> Oh, I must tell you about the cutest little toilets they have down here. Clever to the Nth degree. Built low and form fitting with a foot rest of concrete made in the shape of a shoe so you can place your feet in the proper places. Then they have a grasping bar in front for the more difficult cases and arm rests on the sides when everything is going fine.
>
> Naturally, only the richest people have such luxurys. Some have some sticks laid across a pit in the back yard.
>
> Did I ever tell you about the trip I took thru the cemetery a short time ago? That proved very interesting, so must give a few high points on it.
>
> (2) continued

> (836)
>
> (3)
>
> (letter from John Hedrick, 21 April, 1945, Natal) cont.
>
> Three sides are enclosed by a high wall made of concrete, and a high iron gate at the entrance.
>
> As you walk thru the gate way you are confused by the shape of the wall we it's made in such a way to give the impression it isn't thick but on closer examination, one can see it's at least 3 feet wide since people are buried in it, and about 3 deep.
>
> Then, as you advance into the place, the size, shape, and designs of the stones, and monuments are amazing. Another thing: one person may be buried headed west, and another, north. No system to that, and apparently no family plots.
>
> Some tombs are made similar to a chapel with iron gates. On the inside one may see candles. You know, light a candle in the chapel.
>
> Then all of a sudden, you are thru the first section. Incidentally, the first part of the cemetery are all permanent graves. These have been paid for.
>
> Before I go any further, I must tell you they have permanent, semi-permanent, and temporary graves.
>
> The semi's are rented. That is, the space is rented. Each has a little fence around it and the owners pay a fixed sum each month.
>
> Next, comes the temporary. They are there only as long as the bill is paid. When that stops, the body is exhumed and burned, but in the process of digging it up, a few bones get scattered; so you can expect to find anything down in that section. I actually saw enough bones to complete the human skeleton. I know you won't believe it, but it's the truth.
>
> In this cemetery is a beautiful tomb with 2 statues made of white marble.
>
> The story goes that the belle of Natal suddenly died only a few months prior to her marriage and her mother died shortly afterwards of a broken heart. Both are buried there, plus this gal's trousseau, piano, sewing machine, (everyone has a sewing machine in Brazil), silver, furniture and God knows what else.
>
> Then off to one side is the "Mortuary" where the poor people who can't afford funerals bring the bodies and leave them. At the end of the day a Doctor comes and verified the death, then
>
> (3) continued

> (837)
>
> (4)
>
> (letter from John Hedrick, 21 April, 1945, Natal) cont.
>
> the body is burned. That particular day there were 2 boxes. Each contained a baby. One was in a common shoe box.
>
> It's nothing unusual to see a group of children ranging in age from 4 or 5 to 15 taking a body to the cemetery. They go tripping along, laughing, singing, kicking up pebbles, etc.
>
> Another thing very unusual about the place was the fact that Jews, Protestants, and Catholics are buried in the same place side by side.
>
> Well, I have started doing my own laundry. Underwear and socks. Last time I got my laundry back I had 8 pair of socks belonging to someone else and not one of mine. Believe me I was fit to be tied. That was the straw that broke the camel's back.
>
> Everyone is laughing at me but I don't care. I just go ahead with my business. At least my clothes are clean and I know they're mine, and that's one thing I could never depend on before.
>
> I had planned on going to the beach this afternoon but about 11:30 this A.M. I found I had to work. So I'm writing letters. There's nothing like getting paid for your writing.
>
> I must close for this time however.
>
> Love,
> John
>
> ###

Oh, you must know that I searched and searched for images of cemeteries in Brazil during 1944. I also searched in vain for The Belle of Napal. All that I could come up with is this much more recent photo:

Just in case you are wondering what in the world the U.S. was doing in Brazil during World War II, I have gathered up some information about that. Apparently, Brazil had decided to side with the U.S. and to boycott all things German. In 1940, the U.S. began building and staffing bases in Napal and Recife (among other cities). After Pearl Harbor was attacked, they increased their presence there. So, there you are, my friends. I hope that you enjoyed this post as much as I did! That Uncle John is quite a writer, isn't he?

Oregon Gifts of Comfort and Joy : My name is Kathy Matthews and I live in Central Oregon with my best friend husband, Cary. I am a fifth generation Oregonian who loves to spotlight early Oregon history, take pictures, write, create, spend time with my large family, teach preschool and travel around the U.S. My main blog, Oregon Gifts, is an online journal, where I try my best to celebrate the positive portions of everyday life. My other blogs are off-shoots into my particular interest areas. I began blogging in November 2008, and this is my 2008th post on this blog!

GROWING UP – IN HER OWN WORDS by Doris Graham Cleage

I am re-sharing a piece written by my mother, Doris Graham Cleage, which I first shared in February 2011. I am going to let her tell you about her home life and early years in this piece compiled from some of her writings when she was in her 50s. This is my entry for Jasia's 103rd Carnival of Genealogy, Women's History and for Sepia Saturday #63.

In Her Own Words

My mother in the cherry tree in the yard.

My parents married in Montgomery, went to Detroit and roomed with good friends from home, Aunt Jean and Uncle Mose Walker (not really related) A favorite way to pay for your house was to take in roomers from home and it was a good way for them to accumulate a down payment on their own house.

Mary Vee was born in this house. It was a very difficult delivery, labor was several days long. The doctor, whose name was Ames, was a big time black society doctor, who poured too much ether on the gauze over Mother's face when the time for delivery came. Mother's face was so badly burned that everyone, including the doctor, thought she would be terribly scared over at least half of it. But she worked with it and prayed over it and all traces of it went away. Mary Vee's foot was turned inward. I don't know if this was the fault of the doctor or not, but she wore a brace for years.

Finally that year ended and they bought a flat together with Uncle Cliff and Aunt Gwen (not really related). Mother got pregnant again very soon. Mershell Jr. was born the next year, 1921. I can imagine how she must have felt. She had never kept house, never cooked and never really had someone who told her what to do since she had worked at eighteen. She had never taken care of little children or babies. Meanwhile I guess Daddy was enjoying being the man of the house, treasurer and trustee at Plymouth, with a good job, a good wife and money accumulating in the bank for a home of his own someday.

Mershell Jr. was born in1921 at Dunbar Hospital, with a different doctor. When he was a year old, I was on the way. The flat was too small. Grandmother Jennie T. was consulted, sold the house in Montgomery and moved to Detroit with daughters Daisy and Alice. She and Daddy and Mother bought the Theodore house together in 1923. I was born in Women's hospital and came home to that house where I lived for twenty years, until I married. Mother and Daddy lived in it for 45 years.

Their house. Survey photo.

Grandmother, Daisy and Alice got good jobs, sewing fur coats, clean work and good pay, at Annis Furs (remember it back of Hudson's?) and soon had money to buy their own house, much farther east, on a "nice" street in a "better " neighborhood (no factories) on Harding Ave. While they lived with us I remember violent arguments between Alice and I don't know who – either Grandmother or Daisy or Mother. Certainly not Daddy because when he spoke it was like who (?) in the Bible who said, "When I say go, they goeth. When I say come, they cometh." Most of the time I remember him in the basement, the backyard or presiding at table. Daisy and Grandmother were what we'd call, talkers.

1923, backyard, Detroit – Mary V., Mershell holding my mother Doris.

About four blocks around the corner and down the street from Theodore was a vacant lot where, for some years ,they had a small carnival every year. I don't remember the carnival at all. I never liked rides anyway. Not even the merry-go-round. But I remember it being evening, dark outside and we were on the way home. I don't remember who was there except Daddy and I. He was carrying me because I was sleepy so I must have been very small. I remember my head on his shoulder and how it felt. The best pillow in the world. I remember how high up from the sidewalk I seemed to be. I could hardly see the familiar cracks and printings even when the lights from passing cars lighted things, which was fairly often because we were on Warren Ave. I remember feeling that that's the way things were supposed to be. I hadn't a worry in the world. I was tired, so I was carried. I was sleepy, so I slept. I must have felt like that most of my childhood because it's still a surprise to me that life is hard. Seems that should be a temporary condition.

Mershell holding Doris. Fannie, Mershell Jr and Mary V in front of Plymouth Congregational Church. Detroit.

Boy children are very important to some people and my parents were both pleased to have a son. When Mershell Jr. was killed, run over by a truck on his way to school in 1927, it was a great unhappiness for them. I remember standing beside Mother at the front door. A big policeman stood on the front porch and told her about her child. She did not scream, cry or faint. Daddy was at work. She could not reach him. She put on her hat and coat and went to the hospital. I never saw her helpless. She always did what had to be done.

Mershell Jr, Mary V., my mother Doris in front. On front porch steps. Detroit, Theodore Street.

Howard was born the next year. They both rejoiced for here God had sent a son to replace the one they had lost. He died of scarlet fever at three. When you read carefully the things she wrote, you'll know what this meant to her. But she never took refuge in guilt feelings or hysterics or depressions. She lived everyday as best she could and I never heard her complain.

Ours was a quiet, orderly house. Everything happened on schedule. Everything was planned. There were very few big ups and downs. When Daddy lost his job during the depression and when my brothers died, it was Mother who stayed steady and encouraging and took each day as it came. Daddy would be very depressed and Mother must have been too, but she never let on. I do remember one day when I was about seven and Howard had just died. I came into the kitchen to get a drink of water. She was at the sink peeling potatoes for dinner and tears were running down her cheeks. I don't remember what I said or did but she said, "I will be alright, but you go and keep your father company." I did, and I'm sure her saying that and my constant companionship with my father influenced my life profoundly. She was thinking of him in the midst of what was, I think the most unhappy time in her life. How could God send them a second son and then take him, too?

I remember…when I was very young seven or eight – if I got very angry I would go upstairs by myself-take an old school notebook and write, "I will not be angry" over and over until I wasn't angry anymore. Anger was rarely expressed in our house. I only remember my father and mother arguing twice as long as I lived at home – and I was twenty before I left. But my sister and I fought often. Antagonism was the strongest feeling we had for each other.

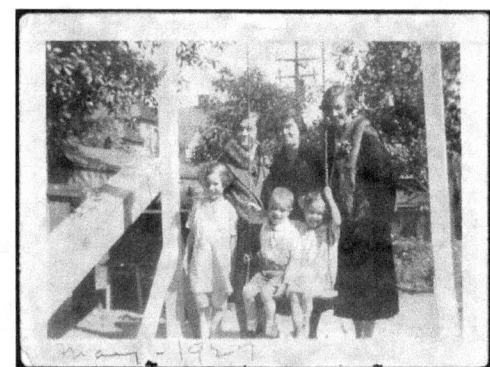

Back: Aunt Daisy, Grandmother Turner, my grandmother Fannie. Front: Mary V. Mershell Jr and my mother Doris. 1927, backyard Theodore, Detroit.

Aunt Daisy took us downtown to the show every summer and to Saunders for ice cream afterward. And I always ended up with a splitting headache. Too much high living I guess. She and Alice would buy us dainty, expensive little dresses from Siegel's or Himelhoch's. They all went to church every Sunday at Plymouth (Congregational). Daisy always gave us beautiful tins of gorgeous Christmas candy, that white kind filled with gooey black walnut stuff, those gooey raspberry kind and those hard, pink kind with a nut inside, also chocolates, of course!

Photo Right : From top: my grandmother Fannie, my mother Doris picking something off of baby Howard who is held by my grandfather Mershell. Backyard of Theodore house, Detroit.

I lived at home until I finished college and married. Everyday when I got home from school the minute I opened the door I knew what we were having for dinner. The house would be full of the good smell of spaghetti or meat loaf or greens or salmon croquettes or pork chops and gravy or steak and onions. We had hot biscuits or muffins every day. My father did not like "store bought" bread. I hardly knew what it tasted like until I married. Our friends were welcome. The house was clean. Our clothes were clean and mended.

Mother often spoke of friends in Montgomery but I never knew her to have a close friend. She was friendly with everyone, especially the Deaconesses with whom she worked at church. She was basically very reserved and what people call today a "very private person". I don't remember ever hearing her say "I want" for herself. Oh, she often said, "I want the best for my girls" or "I want you to be good girls" but I never heard her say "I want a new dress... or a day off... or a chocolate bar..." and I never heard her say "I feel this way or that" except sometimes she said, "Oh, I feel so unnecessary." She was a great one for duty, for doing what was called for and not complaining. You could tell when she was displeased by the expression on her face. Whenever she corrected us, she always explained why, so we came pretty early to know what was expected of us and when we erred the displeased expression was all we needed. She didn't nag either. No second and third warning. Yet I don't remember ever being spanked by either parent. If either one said, "Did you hear what I said?", that did it. We never talked back to them. We did things we knew we weren't supposed to do like all children, but we were careful not to get caught. When we did get caught, we were horrified. I never felt confined and resentful, but Mary Vee did.

Mother had some of the same reserve with us that she had with strangers. We rarely talked about feelings, good or bad. She and Daddy tried to keep things as even and calm as possible all the time. So everybody cried alone although you always knew they would do anything for you because they did. You didn't bring your problems home and share them. You came home and found the strength to deal with those problems. At least I did. If you needed help, you asked for it, but first you did everything you could. I don't think they ever said no to either of us when we asked for help and that extended to grandchildren too.

Memories of her grandmother, Jennie V. Turner
I remember her laughing and singing and dancing around the house on Theodore. She was short, about five feet I guess, with brown eyes, thin dark brown hair that she wore in a knot. She was very energetic, always walking fast. She always wore oxfords, often on the wrong feet, and never had time to change them. We used to love to tell her that her shoes were on the wrong feet. (smart kids!)

She never did things with us like read to us or play with us, but she made us little dresses. I remember two in particular she made me that I especially liked. My "candy-striped" dress – a red white and blue small print percale. She put a small pleated ruffle around the collar and a larger one around the bottom. I was about five, I guess, and I really thought I was cool! the other favorite was an "ensemble" – thin, pale green material with a small printed blue green and red flower in it – just a straight sleeveless dress with neck and sleeves piped in navy blue – and a three – quarter length coat of the same material – also straight -with long sleeves and lapels – also piped in navy blue. She never used a pattern. Saw something and made it! She taught us some embroidery which she did beautifully but not often. She never fussed at us – never criticized – and I think she rocked me in the upstairs hall on Theodore when I was little and sick. The rocker Daddy made stood in that hall. I remember lots of people rocking in that chair when I was small.

Kristin Cleage, former revolutionary librarian, back to the lander, mother of many and family historian. I spend way too much time on the computer posting from Atlanta, GA at present but also from Massachusetts, Michigan, Mississippi and Missouri.

READING NEWSPAPERS, MAGAZINES, BOOKS, & ALL

This is my Mom in the mid 1930's reading as she walks along a street in San Francisco. The picture was taken by my Dad before they were married. They worked for the same company but in different departments and had never actually met. He worked in the mail dept. and walked by her desk every day but never had a reason to do much more than smile at her as he went by. He thought perhaps presenting the photo to her would be a good way to 'officially' meet her . . . and, as it turned out, it was!

Reading on the ferry – but not on their way to work. These people look much too happy for that. No, this was a group of young, mostly single, folks who worked for the same company Mom and Dad did on their way to a Sunday hike and picnic on Mount Tamalpais – crossing the Golden Gate from San Francisco to Marin Co. on a ferry before the famous bridge was built

Okay, this picture is definitely proof these people are not on their way to work! I wonder what ails the folks in the front seats of both these pictures, though? They don't seem to be having anywhere near as much fun as the folks in the back! Hmmm? Perhaps a boat trip across the waves is not their cup of tea?

Not sure what my sister, Meredith - reading a recipe off a box of Bisquick - was making here? Apparently it needed a taste test. It looks like there's a pile of nuts on the counter behind her – I see a nutcracker. I don't remember if whatever she was concocting turned out well? Hopefully, if she read the recipe correctly, it did.

Our family used to make it up to the snow from the Bay Area at least once every winter. Here, my brother, Steve and sister, Cindy are reading the Sunday paper in a cabin at a place called "Daum's Village" in South Lake Tahoe. Unfortunately, the original "Daum's Village" of separate little cabins no longer exists – replaced by an on ordinary 'cookie cutter' motel that looks like all the others along the strip. Such a shame, but that's progress I guess.

I was there too, reading the Sunday paper. Looks like I might have had the funnies? I think this was the trip when it started snowing seriously on our way home over Donner Pass. The windshield wipers could barely keep up with the blizzarding snow and Dad was having a difficult time watching the snow-covered highway through a small hole in the snow on the windshield.

Meanwhile, Mom was looking out a side window exclaiming: "Oh! Isn't this beautiful." to which Dad replied gruffly: "Yeah. Yeah. Beautiful." Mom was a little startled at that. Fortunately, we all laughed.

This was Daum's Village - such a quaint place featuring cute well-furnished cabins with big stone fireplaces - though the rooms were heated otherwise, as well. Still, a nice wood fire in a big stone fireplace in a cabin in the mountains in the snow is just simply cozy and cheerful. I'm sure the motel rooms replacing the cabins didn't have stone fireplaces or warm knotty pine walls. Phoo!

Fast forward a few years to a good book, a warm summer afternoon, and a kindly older brother willing to read to his little sister. (son, Ross and daughter, Suzanne)

Turnabout's fair play. As her brother read to her, so Suz reads to her dollies. (I think I eventually sewed another eye on poor Patchella.)

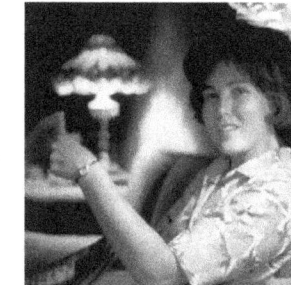

And here I am again, reading the evening newspaper at home after a hard (well, not really) day at work in the '60's. I was a receptionist for a large company – greeting people, answering phones, and occasionally typing something. For a decidedly social person like myself, it was the perfect job.

Other folks enjoy reading stories too . . . albeit in a rather bouffant manner.

A soldier reads an officially announced telegram.

And last, but by no means least, here is something for everyone to read. In looking through old family photos, I came across this poem my Mom gave to my Dad when they were courting. She said they often exchanged little 'love notes'. She can't remember exactly where the words came from. She thinks they're from a song rather than a poem. I searched on line, but couldn't find anything. If anyone knows anything about it, please let me know. Mom and Dad were married for 46 ½ loving years.

La Nightingail

"La Nightingail' is Gail Perlee from Soulsbyville, California in the Sierra Nevada Mountains near Yosemite National Park. Living in the mountains is heaven for me, and I'm rather into the arts as is probably evident from some of my posts. I sing, love making a fool of myself onstage, and still dance a little (tap shoes remain handy on a shelf in the closet). I sketch and write (novels & short stories – as yet unpublished, but hope survives.) For fun, I draw house plans, and I'm an avid reader – mostly of historical romance which is what I write. I also enjoy climbing our family tree, and I knit a bit – for KAS (Knit-A-Square

> And what are you that, missing you,
> I should be kept awake
> As many nights as there are days
> With weeping for your sake?
>
> And what are you that, missing you
> As many days as crawl
> I should be listening to the wind
> And looking at the wall?
>
> I know a man that's a braver man
> And twenty men as kind,
> And what are you, that you should be
> The one man in my mind?
>
> Yet women's ways are witless ways,
> As any sage will tell, –
> And what am I, that I should love
> So wisely and so well ?!

Larry Burgus (LD) : Larry's Sepia Saturday

MY FAMILY

The Sepia Saturday bloggers are celebrating the fact that they are still being on board after 199 posted blog weeks. To remember the past as well as to honor it, we have continued to post pictures and words for everyone to enjoy.

This is a reposted blog from the year 2010. I joined the Sepia Saturday group in February of 2010. It is entitled "My Family..." which is a posting of everyone before I was born.

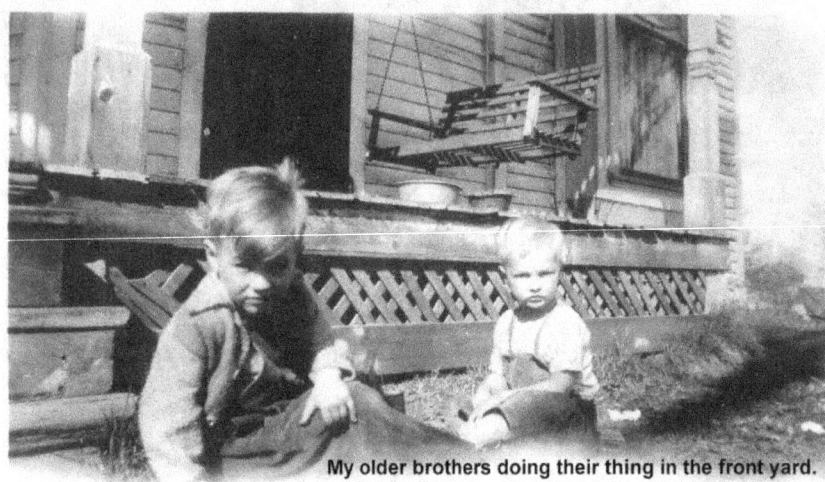

My older brothers doing their thing in the front yard.

Ronald James Burgus looks into the camera while his younger brother Rex Thomas Burgus checks out the person taking the photo. While my dad was in the service in Washington D.C. and then in Europe, these guys and mom lived with Grandma Brown, mom's mother. This is in Murray, Iowa and I suspect the year is 1945. Ron would be 16 months older and I think he looks close to being four years old here. The house in which they are sitting still stands today, except some time after they lived there the owner removed the second story and made it look like a ranch house.

After dad returned from the war, Dwight Lee was born in Feb. 1947. At first my dad worked as a mechanic, repairing tractors. He then made his move to become a farmer. They rented a farm in which dad would give up half of the crop for the rent. This photo is taken out on that farm, south of Murray, near a little town called Hopeville. Someday I will blog about Hopeville.

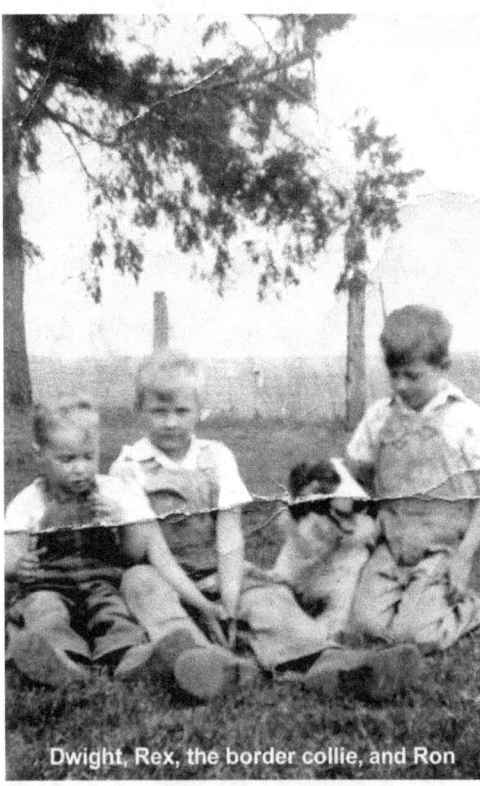

Dwight, Rex, the border collie, and Ron

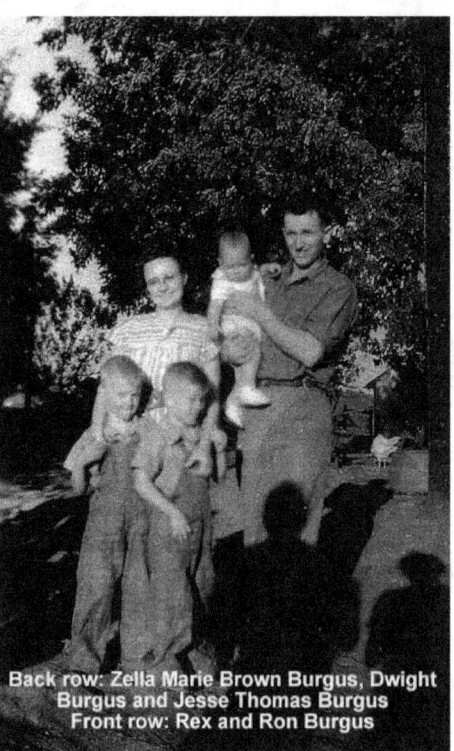

Back row: Zella Marie Brown Burgus, Dwight Burgus and Jesse Thomas Burgus
Front row: Rex and Ron Burgus

This photo was taken out on the rented farm in 1949 or 50. It was south of Murray, Iowa. I was born in 1950 and I think Dwight looks almost three here. I could have been born by then but I really didn't remember living on that farm except for a few times when I was three years old. One story I have heard from the family about the dog was that he was so protective of his family and no one else was welcomed on the property. A border collie is such a loyal dog and he was lost when we moved to a new farm in 1953.

Today Ron owns a printing company in Mesa, Arizona and Rex co-owns with two partners a company that make trailers for recreation vehicles in California. Dwight started his working life as a construction worker, working as a contractor for building companies in Mesa, Arizona. As his addictions continued in his life he demoted himself to

being a drywall installer and then a part time carpenter. He had to start living with my parents back in Osceola, Iowa in his later years. My father died in 2000, age 82 and my mom passed away in 2008, age 89 years, three months after her death my brother Dwight died. He was 61 years old.

As I create these blogs I find it difficult to edit and cut them to a reasonable size. Of course I know so much more about this era and I can't begin to touch it. And yet it is satisfying to put it down and to share it. The photos do speak volumes and that is what makes Sepia Saturday so fulfilling. If I am weak in spirit on the day that I write, the photos help me save face. I do so enjoy being a part of this process and have grown so much in my ability to observe and to express the past world around me.

LD is originally a southern Iowa farm boy who has made his way in the world by teaching and learning from others. Art teacher was his main title for most of his life even though it extends into computer tech, carpenter, gardener and one obsessed blogger. He still lives on the prairie so to speak in central Iowa with his wife and dogs.

Lorraine Phelan : Backtracking

FLOWERS AND CROSSES

Two men in suits, yarning in the doorway of a coffee lounge. That's the theme photo for this week's Sepia Saturday. So of course I ignored the men and went with some of the signage on the wall. On the left side of the photo there is a florists's sign that reads 'Wreaths and Crosses' and I'm following that link in this blog. In World War 1 a relative was sent an album of pressed flowers from the Holy Land and Jerusalem. There are about 12 pages like those below. The album is about A4 size and has a cover made of olive wood. Some of the pages have crosses, some not. The flowers are in remarkably good condition and retain a lot of colour.

 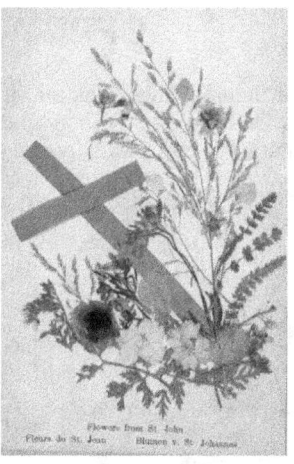

Also during the war a family member, David Ray Leed, was killed in France. This photo was sent to his parents.

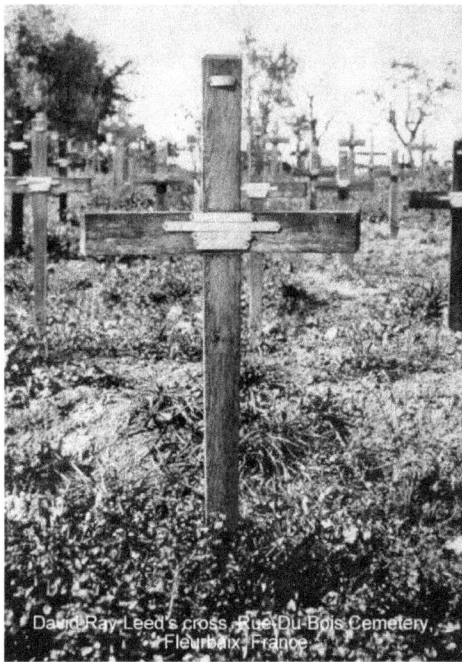 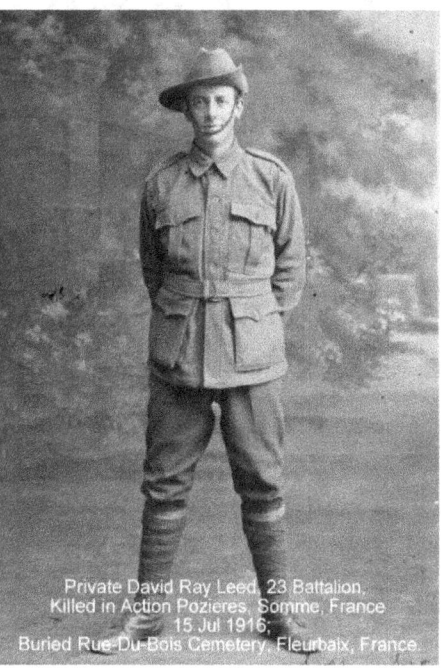

About 15 years ago friends of ours visited the cemetery and gave us these photos as well as a pressed red poppy they gathered from a field there. As you can see, the cemetery looks much different now. It's under the care of the Commonwealth War Graves Commission.

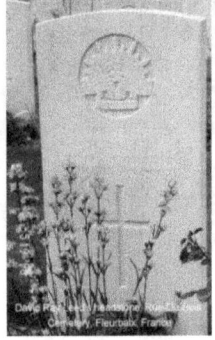 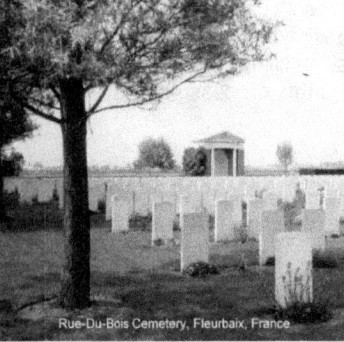

At about the same time, between 1910 and 1920, this postcard was sent to a lady in Melbourne for her birthday. Now why would you put a cannon on a birthday card??? Even if it is covered in flowers.

Lorraine Phelan (Boobook) is a retired teacher and lives in Victoria, Australia. She enjoys photography, family history, local history and natural history and unfortunately finds she has little time left for housework.

Marilyn Brindley : Hanging On My Word

OPEN ALL HOURS

We are celebrating at Sepia Saturday this week as we have reached our 200th post. Co-incidentally it is also my 200th blogpost on Hanging On My Word. I wasn't part of the sepia fun at its inception, but now I'm part of the admin team! I decided to share one of my early posts, which is also one of my favourites.

The very detailed pictured provided as a prompt for this week's Sepia Saturday, shows a shop doorway in Sydney, Australia in 1934. This sent me delving into my father's side of the family, where I knew that at least three of them had been shopkeepers. It's amazing what a little research for a blogpost will nudge, quite literally, into the frame. I had always been aware of a blurry sepia picture of my great-grandfather Sydney (Dad's Grandfather on his mother's side) standing in the doorway of his fishmonger's shop in Nottingham. My older brother knew a few more details but also provided me with three new pictures I had never seen before. The first of these is the one I like best; the nonchalant pose is not one I've ever seen adopted by a 'sepia shopkeeper' before!

Now, I know this isn't a fishmonger's, it appears to be a grocer's, so we have a bit of a mystery. Could it be two windows of the same premises? Behind him, in the shop, can be seen tins of biscuits and other dried goods which would have been his stock-in-trade.

A second picture appears to confirm this, though he doesn't look quite so dapper here; waistcoat off and
sleeves rolled up. The child beside him is a friend of the family and the other youngster just happened to have run in front of the intended subjects, as small children so annoyingly can when a shot is being posed. No digital cameras then, and films were precious, so once the shutter clicked it would have to do. This picture seems to pre-date the next one as my Great-grandfather looks a little younger, but it's interesting to note the price of bread is the same as that in the Sepia Saturday prompt. The shop reminds me of the one kept by Arkwright in the TV series 'Open All Hours'. I wonder if it had a similar lethal till (cash register). I talked to my 90 year old father about the fishmongers on Manvers Street, Nottingham. Dad remembers his Grandfather also sold rabbits, and my Grandmother (one of his fourteen children) as a girl, had the job of skinning them. There was sawdust on the shopfloor to catch the blood .

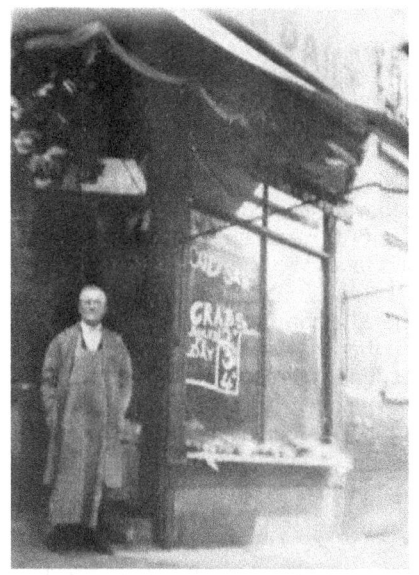

Here's the picture of my Great-grandfather which started me on this quest. Now we see him in yet another working outfit, complete with striped apron, from which he would produce a halfpenny when my Dad visited as a child. The window advertises cod and crabs. I'm told this was Jubilee Day 1934, and the bunting can just be seen above the window and door.

My Dad, who was a travelling salesman, also inherited the selling gene from Lydia, his Grandmother on his Father's side. At some time around the turn of the twentieth century we know that she had what Dad called a 'Bread Shop', but I don't think it was what we would now know as Baker's. It was more likely a corner shop, typical of many a street in town and village at that time. The shop would provide those commodities needed by people with little income, who had only to walk to the end of the road where they lived to buy a loaf or a packet of tea.

The last picture is of yet another member of the family. The lady in the doorway is not Lydia, who died in 1910, but her daughter Sarah (born in 1885). This picture was probably taken in the late 1920s or early 30s. She was my Dad's Aunt 'Cis' who would later run a sweet shop in Delta Street. Cis would have given up her original skilled job, which according to the 1901 census, was that of a lace-hand in Nottingham's famous lace industry. I like the way the children in the street have engineered to be in the photograph; it makes it all the more interesting. The little chap is being given a ride on a bike which is far too big for him - he could never reach the pedals. On the other hand it seems too small for his older sibling. There's another smaller bike on the right, face on to camera. What do we think the youngster on the left is doing? And no, he's not sending a text!

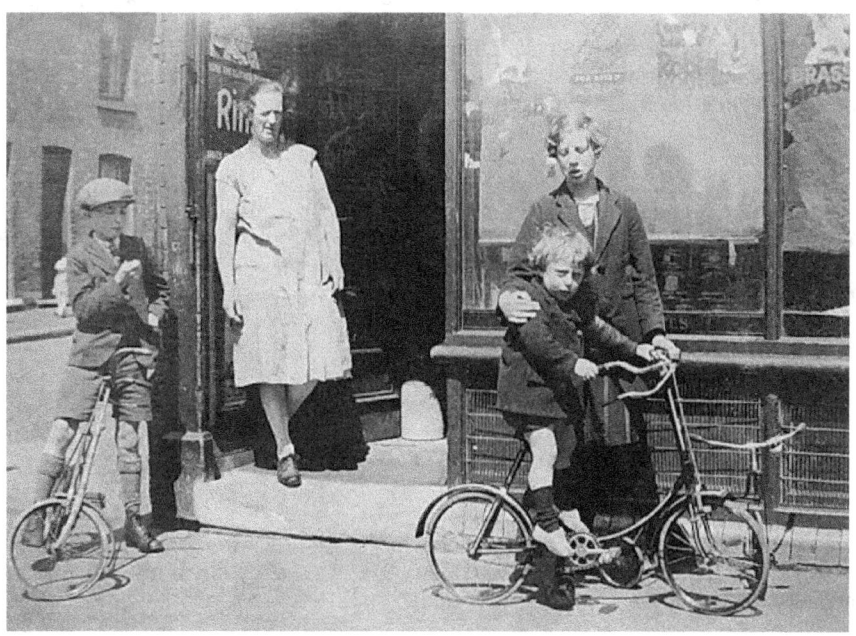

I asked both my parents about the sweetshops of their childhood. Dad recalled Pontefract Cakes, Marshmallows, Tiger Nuts, Turkish Delight and Barley Sugar sticks. Mum remembered that when she was a little girl in the 1920s, she would visit a shop run by the Misses Mackintosh on Tealby Terrace, Nottingham, where 2oz of sweets would cost one penny and a bar of chocolate would be tuppence. There would be fruit drops, dolly mixtures and liquorice sticks. Mum loved walnut whips (a rare treat) and sherbert fountains. "Do you know, she said, I haven't had one of those in years. I wonder if you can still get them. I'll look out for them next time I'm out shopping." Mum will be 91 in November, with a wonderful memory for the small details of her childhood. "Aniseed balls," she said, "We used to suck them until they changed colour, and we'd keep sticking our tongues out to each other to check." She also recalled her friend Tommy who always gave her the little toy from his 'Lucky Bag' for her Doll's House. The simple pleasures of childhood.

Marilyn Brindley (Little Nell) : I am a retired primary school headteacher who moved to Lanzarote for the year-round sunshine, the amazing landscape and the slower pace of life (Mañana really means mañana here). I have been married for 37 years, have a son and daughter and 5year-old twin grandchildren. I relish the time to do what I like at last; get up when I want to, go to bed when I want to. Of course there are things I miss about England: the song of the robin and blackbird in my garden and watching the blue-tits nesting, the theatre, the art galleries, the cathedrals, but I get my fix on the visits back to Blighty and travels further afield. This is my home now, in every sense.

Martha Gibbons : Who Were They?

EDITH A NUNN

Bicycle girl

For this week's Sepia Saturday, I am posting a photo that I've been holding onto for weeks! This is my great grandmother, Edith A Nunn. My dad tells me that Ama, as she was called, was tiny, maybe just around 5 feet tall. You can tell she isn't much bigger than the bicycle she has posed with. It's ironic because I am 6 feet tall and one of my cousins is 6' 5". Amazing what a century of health and nutrition will do for a family!

Edith was born in 1871 in the Sheldon family descended via the McKinstrys and Coles from the Mayflower family of Stephen Hopkins. I don't know if it meant all that much to her family, but we do have a very old family tree, written in red ink for some reason, charting out the lineage. I suppose I could use that to apply for membership in the Mayflower descendants club or whatever it is called, but honestly the last thing I need is another hobby, lol.

So, Edith lived from 1871 to 1944. A while back I posted a photograph of her husband, Albert E. Nunn (Apa) with his brother Herb and sister Lizzie. That particular photograph led an online friend and fellow old photograph collector to speak with her neighbor, who happened to also be related to the Nunn family via another brother. Small world! Edith had five children, three singles and a set of twins. Sadly, one of the twins died at age three.

This photo came with a little story. You will notice that one girl has her hem pulled down while the other's is up and showing the ruffles. As the photographer was setting up the photo, Apa pulled the dress on the left down to match the other dress and at the same time Ama raised the dress on the right. Neither one caught what had happened and the photo was shot as we see it.

Martha Gibbons is a working mom and wife in Southern California USA who enjoys history, blogging, cooking, sewing and all things family. She loves digging into family archives and mysteries hoping to find the threads that tie everyone together. Her site Who Were They? was started as a means to find descendants of those pictured in old photographs to hopefully reunite photos with their kin.

Margaret & Mildred

Martin Hodges : Square Sunshine

MR & MRS LIGHT COME TO TOWN

Well, I've been scratching my head, trying to decide on a post that befits the 200th Sepia Saturday celebration and, finally I have one. First published on 20th November, 2010, it's a story about my Great Great Grandparents, as reported in the Daily Herald on Wednesday, 25th August, 1937.

Two excited old people, Mr. Wellington ("Duke") Light, 78 year-old Hampshire farmer, and his 74 year-old wife, yesterday visited London for the first time.

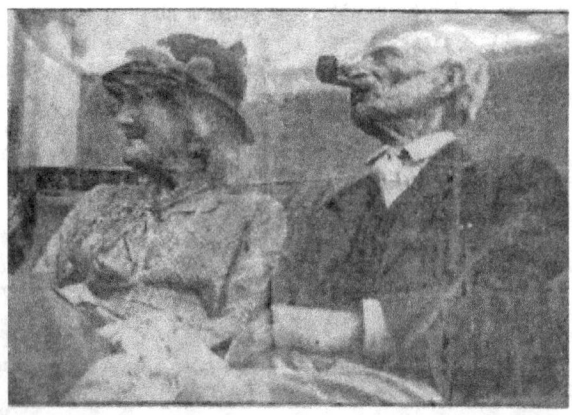

They came as guests of the "Daily Herald" - and their visit fulfilled a life ambition. For, they had never before been more than 25 miles from their home in Colden Common, near Winchester. Married 52 years, they have never been separated, had never ridden in a bus or been to a theatre or cinema. Here is how they spent their day with a "Daily Herald" Special Correspondent, who showed them the sights.

1 P.M. Driving over Westminster Bridge, they catch their first glimpse of the river. "How beautiful," says Mrs Light, "Look Duke, it's just like the sea. And is that Big Ben right up there? We've read all about him in the papers."

1.10 Passing Buckingham Palace. "Is that where the King lives," asks Duke, unbelieving. "why does he have such a great place as that?" Mrs Light interpolated the story of "how we nearly couldn't come to London after all because one of Duke's pigs, which he bought at market yesterday at 22s. each, and very nice little pigs too, escaped and ran away. But it was all right after all. We found him this morning, sleeping in the next sty."

1.15 Mr and Mrs Light shake hands all round at the Royal Palace Hotel. Going up to their room they take their first trip in a lift. "What?" says "Duke," again incredulous, "Up three flights of stairs in about a second. I never would have believed. If that isn't a licker."

2 P.M. Lunch in the Cumberland Grill. Says "Duke," pointing to the concealed lights, "Is that the sun coming in there? No? It must be some wonderful lights."

Later, he tells the waiter how he nearly couldn't come to London because of the lost pig, lights a cigar and clears up the Stilton.

3.30 "What high buildings you have up here" (around Marble Arch) "I never dreamt there were such places."

4.15 At the Bank of England, they see "where the money comes from," and watch the pigeons outside the Royal Exchange.
"I used to keep pigeons," says Mrs Light, "but the cat killed them all. Does anybody ever feed these, (anxiously) I thought they looked well fed."

5 P.M. "I do believe my man will want to come and live here," she adds, as the car slips along the Embankment. "Well, I've heard a lot about London, but I never would have believed," says "Duke." "What a mighty place it is to be sure."

5.30 "marvellous, marvellous" they both say in Hyde Park. "You Londoners ought never to want for fresh air."

6 P.M. Mrs Light tells the manager of the hotel all about the day (and about the lost pig).

Mr Light explains to the Hall Porter that "it's the best day I ever did spend. Fifty two years we've been married, last Monday as ever was, but I never dreamed of anything like this and that's the truth."

8 P.M. At the News Theatre, they see their first pictures. "It's hard to think it isn't real," whispers "Duke," in my ear. "I've read about the pictures, but I never would have believed…"

Later he confesses that the Silly Symphony, "Father Noah's Ark," troubled him a little. "I don't like mockery…"

9 P.M. On the way back to the hotel. "I've told that manager man," says Mrs Light, not to be surprised if I'm up at 5 o'clock tomorrow raking the fires about. He did laugh!" They decided that tomorrow they would like to see the Zoo.

My Grandmother told me that Duke and Jinny had their trip to the Zoo, but although they knew the animals were well cared for, it upset them both to see them in captivity. At that point, Jinny became homesick. She thought about her cows, wandering free in the meadows, and suddenly she felt like a prisoner. She was never one to mince words, and duly informed her hosts that she had seen enough and wanted to go home.

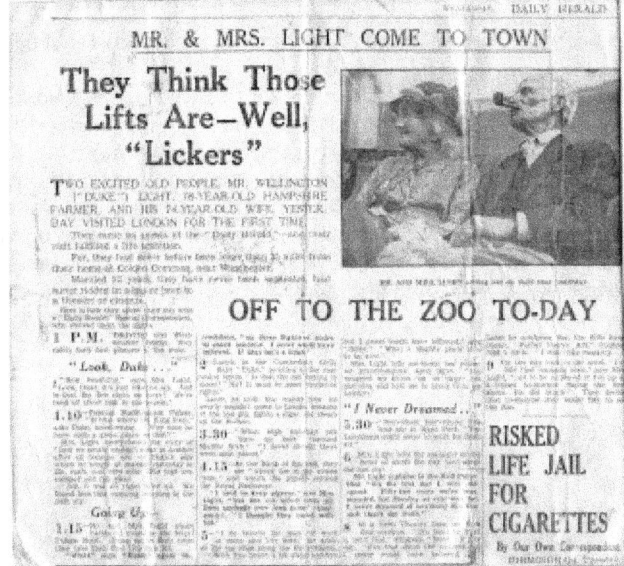

On their return, Duke was asked if he had been nervous about anything. "Only of the bath," he exclaimed, "we're only used to an inch or two in the tin bath in front of the range. In the hotel, the maid had filled the bath three parts full!" This, he thought, was wasteful.

Martin Hodges : During the 80s recession, a provincial Sunday tabloid offered me a column for thirteen weeks — it ran for two years. I've been a labourer, lorry driver, project manager and editor. I have letters after my name, which rearrange alarmingly as, Shuddering Phobia Pump. I managed to hop off the hamster's wheel in 2006, without damaging my writing hand.

Mike Brubaker : TempoSenzaTempo

A BAND FOR JUNETEENTH

This weekend we are celebrating the special 200th edition of Sepia Saturday, an internet club that I have been proud to participate in since the Sepia Saturday No. 56 of January 8, 2011, and everyone has been challenged to submit their favorite entry from the last 200 thematic prompts. At the time I joined, it seemed like just an entertaining way to add readership to a blog, but I soon learned that I was linking into a new type of media, a kind of weekly internet digest. Its imaginative editor-in-chief, Alan Burnett, produced this magazine by inviting bloggers from around the globe to focus their attention on an unusual black and white photograph and then write their own story based on similar old photos. Now nearly three years later, I have used Alan's clever choice of subject (or sometimes those of his wonderful assistants) as the inspiration for every post on my website.

Not only has it influenced my choice of photo story, but it has been the best defense against that bête noire of authors, the writer's block. Alan's perceptive insight on the hidden story inside an image, has led me and my fellow Sepian contributors to look beyond the camera lens and search for shadows of forgotten time. Those shades often have great tales to tell, though sometimes, just like ghosts, there really is nothing there. But that's part of the fun too.

It also has been a great delight to meet so many people who share Alan's wonder of vintage photos. Not only have they expanded my knowledge of history and geography, but I have been introduced to countless fascinating families, collections, and interests. We've become one gigantic interrelated clan, as I'm quite sure I am not the only one who thinks Alan's Uncle Frank and Aunt Miriam are part of their own family tree.

The best part of Sepia Saturday though, has been following the many creative writers who all share an insatiable curiosity and a love for a good story. The photos may inspire but the good writing will easily keep us going on to number 300. So thank you, Alan. And my thanks to each of you who have read my stories through Sepia Saturday.

As the unofficial music correspondent of the Sepia Saturday group, it was very hard to select just one musical post from my blog. The title of my website, TempoSenzaTempo comes from fusing together two common Italian words used in music - Time Without Time. It describes the characteristic of many of the anonymous photographs in my collection: unknown musicians from some unidentified place and some forgotten time.

The story I chose comes from earlier this year and was inspired by the theme image for Sepia Saturday No. 161. It's an 1890s photo of a fruit and oyster vendor in Raleigh, North Carolina, which just happens to be the state where I live. This typical street view shows two merchants in front of their shop and just to one side stands an unidentified black man, perhaps an employee, who adds an intriguing element to the picture. By chance, Alan's theme came on the week that the United States inaugurated Barack Obama to a second term as President. And this event also occurred on the national holiday celebrating Martin Luther King Jr.

It happened that I had an anonymous photo that fit perfectly with this alignment of themes, and inspired by my friends on Sepia Saturday who have encouraged my fiction, I invented the following story. I hope you enjoy this reprise.

A Band for Juneteenth

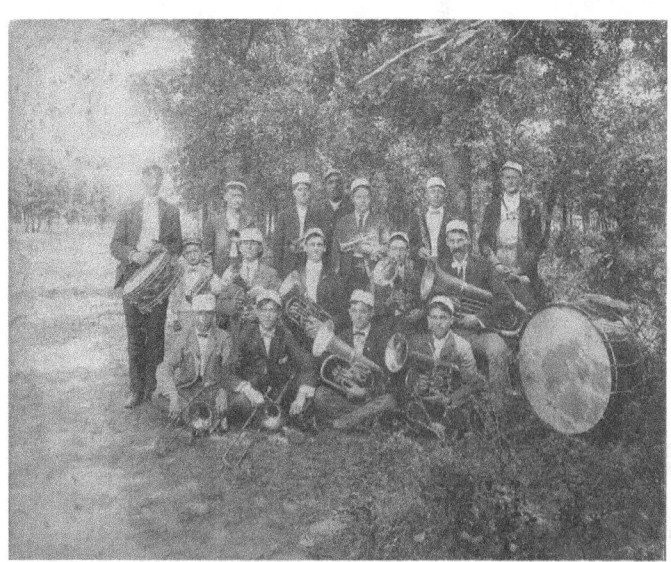

A short fiction glimpsed through the summer haze of an old photograph

It was still early in the afternoon, and being a Sunday, people were in no hurry to get to the park. The teams had yet to arrive, so no one was up in the bleachers. Hal took the band through the march one more time.

"No, no, no," he shouted. "Something's not right." The music sputtered to a stop. George gave one last thud on his bass drum. "That last part wasn't even close to the right speed. And you," said Hal, pointing to the trombones, "are playing it all wrong or something." He squinted at the music on his stand. "I know Mr. Sousa didn't write it that way."

The boys looked at one another. Henry called out from the back, "Maybe Tom's got gum on his shoe again and can't tap his toe." They giggled. And laughed again when a loud burp came from one of the tenor horns.

"Would you all just keep quiet a minute and let me figure this out," cried Hal. He scratched his ear and frowned at the music. He looked toward the fence where a man was sitting on a picnic table. "Say Franklin, can you make out what the problem is?"

The tall black man came over to the band and smiled at the boys. "Well Mr. Hal, I was listening right close and I think when the tune comes round again, some'a you cornets played an extra bar." He looked at the trombones. "And there's a queer note sounding in that 'companiment."

"Dang it, Milton," said Hal. "That's an A-flat. Watch your key signature." He twisted the curl on his mustache. "Cornets did you get that? The second time through you got to skip over that first repeat. Show them how it goes, Franklin."

Franklin drew a breath and in a deep voice sang their part, adding emphasis to the correct pitch. He gave a nod toward the drummer. "Mr. Francis, you could help them out with the rhythm there too. Taaa, tuh, ta, ta, ta. Taaa, tuh, ta, ta, ta. Ta, ta, ta, Taaa, tuh, taaa"

Hal picked up his tuba. "Alright. Let's give her another push, and maybe get her going down the right track. From the top. ONE, TWO. ONE, TWO." The music stumbled along with a melody that stayed mostly upright. Franklin stood to the side waving his hand to the beat.

The band finished and Hal could see that the crowd in the grandstand was getting larger now. "Take a short break, fellas. Leo, you keep next to your brother and don't go wandering." They placed their instruments down on a bench near the diamond's backstop. . "And don't forget," he called, "we got a photographer from Marshall's going to take our picture after the game!"

Just past the assembly of wagons and pony traps over at the corner, some of the players were getting off the street car. The umpire had unpacked his bag and was setting out the bases. There was a pleasant summer taste to the air. It was a fine day for baseball.

Hal re-shuffled his stack of music. "I sure am glad for your help, Franklin. Ever since Mr. Holloway left, we've been lacking a good ear." He set his tuba down by the bench and walked over to the table. "We don't play the Tremont team too often. Shame we couldn't do it on Flag Day, but that rain last week was enough to float Noah's boat. It would have made a real special day for the band."

"Yes, sir, Mr. Hal, but it's still a special day alright." He smiled at the sky. "It be Juneteenth. A very special day"

Hal frowned. "Juneteenth? Oh, you mean June 19th."

"No, I mean Juneteenth. The day Mr. Lincoln freed the slaves." He smiled again. "My daddy was in Galveston back then, and ever since I was a little'un we always celebrate Juneteenth. Now since I come up here though, there not many black folk around to remember with."

"I never took you for a Texas cowboy, Franklin." Hal pulled out his watch and checked the time. "Now I recollect my paw used to talk about Emancipation Day being in January. He served with the 36th Illinois Volunteers."

"Well down in Washington D of C they take their day in April, and others got January or September. But daddy always said that to hear those words was to hear a rainbow, so I always liked Juneteenth."

Hal watched his friend sigh and thought back to the stories his own father had told. All along the campaign, from the mountains in Tennessee to the ocean in Georgia, he had seen countless black people rejoice at liberation. That wondrous joy had made the terrible great burden of war easier to bear.

Hal saw the umpire was waving the players onto the field. "Come on boys, let's form the circle," he said picking up his tuba. He motioned to Franklin. "Get your self in the center and lead us through the anthem, Mr. Franklin. I 'spect this town needs a Juneteenth jubilee song."

There was no need for the folios as the boys knew this tune from heart. George and Francis struck up the drum roll. Franklin turned to the flag now waving in a light breeze, and his strong baritone soared above the ball field noise.

My country, 'tis of thee,
Sweet land of liberty,
Of thee I sing;
Land where my fathers died,
Land of the pilgrims' pride,
From ev'ry mountainside
Let freedom ring!

My native country, thee,
Land of the noble free,
Thy name I love;
I love thy rocks and rills,
Thy woods and templed hills;
My heart with rapture thrills,
Like that above.

Let music swell the breeze,
And ring from all the trees
Sweet freedom's song;
Let mortal tongues awake;
Let all that breathe partake;
Let rocks their silence break,
The sound prolong.

Our fathers' God to Thee,
Author of liberty,
To Thee we sing.
Long may our land be bright,
With freedom's holy light,
Protect us by Thy might,
Great God our King.

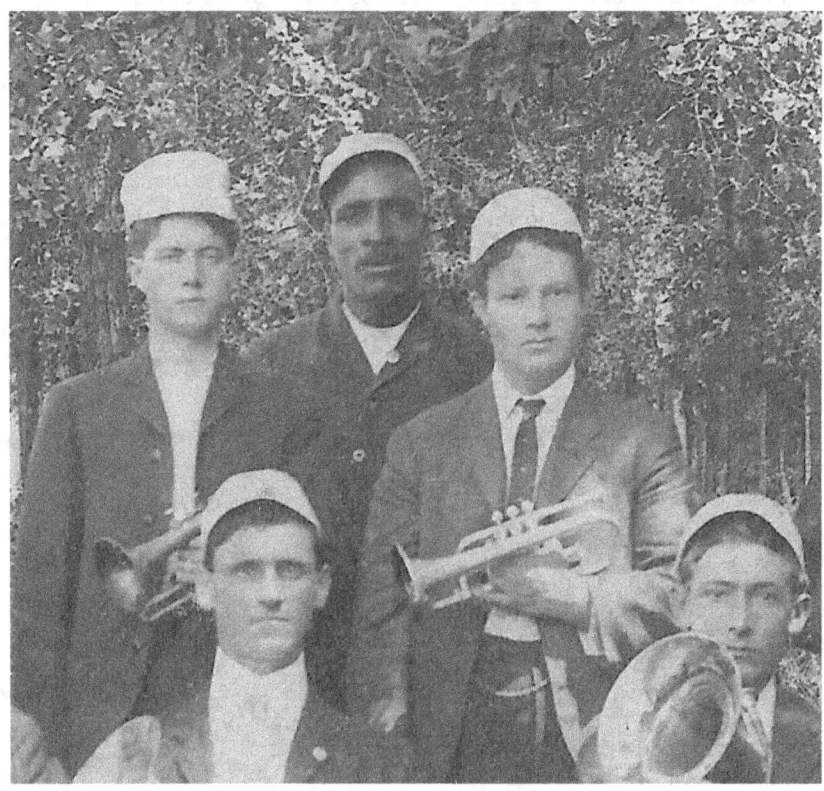

Lost in time and space, this photograph of an unknown band was never meant to be anything but a memento of a day. But it had one element that made it different from the thousands of similar photos of bands from the 1900s - a black face. We can't know if this man played an instrument or just drove the wagon, but since he wears the same simple uniform cap, there is a small sense of inclusion, perhaps even acceptance of this man in an era when African-Americans were not afforded an equal place in society.

On this week where we commemorate the dreams of Martin Luther King Jr. and inaugurate President Barack Obama to a second term as leader of our nation, it seemed fitting to use the Sepia Saturday theme photo to inspire a small story about how far our country has moved. Juneteenth is a real holiday that deserves to be celebrated by all Americans. And despite today's over production performances of the Star Spangled Banner, in 1900 it was not the usual national anthem performed in most small towns and America, perhaps because it is easier to sing, was the better known patriotic song.

Mike Brubaker is a professional musician who plays the horn in several orchestras and chamber groups in southeastern United States. He also collects antique photographs and postcards of musicians and musical groups, and writes stories and histories about them on his blog. He lives in Asheville, North Carolina.

Nancy Messier : My Ancestors And Me

REFRESHING AN INDELIBLE IMAGE

Fanfare, please! Sepia Saturday is celebrating its 200th round today and those of us who have participated during that time are celebrating, too, by reposting one of our favorite, earlier Sepia Saturday posts. I first participated in May, 2010, and have published over 60 posts, which makes it terribly hard to choose a favorite. In the early years there were no themes (such fun that way!): we just chose a photo from our collection and wrote about it, then linked up. Thank you to Alan and Kat for creating Sepia Saturday and to Alan and Marilyn for keeping it going. It's been fun.

But back to the subject at hand: which post to repost for this celebration? The post about the clocks in our home? The one about my great-grandfather's confectionery? About the student nurses? About my grandmother and her lovely waist? My father as a young man? None of those, after all. It's this one: a moment in time, an action repeated time and again.

~-~-~-~-~-~-~-~-~-~

In my life there have been events that were continually repeated, events I saw so often that I learned them by heart and they became indelible images in my brain. I begin to notice, as time passes and I grow older, that a light fog sometimes comes between me and the memories. And then I see a photograph and the scene is as fresh as the last time I saw it in real life.

Our house was a house of order and part of that order was this closet in our kitchen next to the back door. As soon as we came in the house, we hung our coats and put our hats and mittens on the shelf, ready to wear them when we left again. My mother also stored large, lidded metal cans of sugar and flour in this closet, ready to refill her canisters on the kitchen counter. In the fall, there were always bags of Northern Spy apples sitting on the floor of the closet. They stayed cool and fresh there because the unheated closet was against two outside walls. Apples were our after-school snack -- our only after-school snack. So "you won't spoil your dinner," my mother used to say.

This is my father, Lee Doyle, standing in front of the closet getting ready to leave. Dad always wore a hat when he went outside: summer, winter, rain, snow, heat, humidity, he always wore a hat, though not always the same hat. In summer he wore straw or cotton. In winter he wore felt or wool. His work hats were caps with a brim on the front. He wore those to work at Copperweld Steel or when he was working at home cleaning gutters, mowing the lawn, or painting the house. Otherwise, his hats were always grey or black fedoras. When he was younger the brims were wider; as he grew older, he chose hats with slightly narrower brims (as in this photo). His hats had no feathers.

He took the jacket or coat out of the closet, put it on, adjusted it, then zipped it. Or if it was a sweater, he buttoned it. When he put on his hat I remember him adjusting it just so: it didn't perch, neither did it sit too low, but it was low enough and tight enough that the wind didn't blow it off. He took the car keys from on top of the refrigerator (to the left in this photograph) and then out the door to the car or the garage or to walk to the post office he went. I suspect that because it was April when this photo was taken, it was warm enough outside that he didn't need a jacket.

Things we see thousands of times we learn by heart. By heart I remember my father putting on his jacket and hat. What a commonplace thing to remember. What a commonplace thing to photograph! And yet it brings pleasure -- and sometimes just a touch of melancholy -- to clear the fog and refresh my memory of that small action.

Nancy, living in central Ohio, spends too much time researching, thinking about, and writing about her ancestors. She also enjoys spending time with her living family members and her Airedale, Hannah.

MAYDAY! MAYDAY! MAYDAY!

I had a feeling that May poles, May queens and May baskets might all be written about this week. So I've decided instead to use the term Mayday, the distress signal, as my inspiration for this post. And I'm tying it to the Titanic disaster even though the signals coming from the sinking ship were CQD and later SOS, not Mayday.

This is Harold Bride in the message room of the Titanic. Doesn't this photo have a ghostly quality to it?

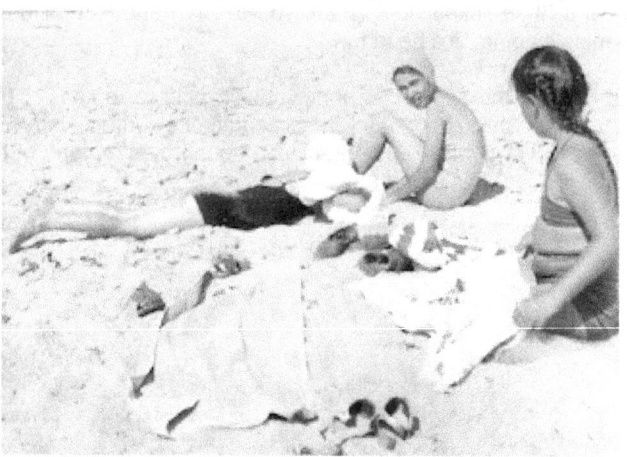

Barbara and me and friend (under the towel)

Now let's go back to 1956, not 1912. Our neighbors the Holts invited our family to join them in Laguna Beach for a vacation. They had 2 cottages where we all could stay. But we had to share the cottages with their 2 maiden aunts. We were told not to talk too much to the one aunt because she was very shy, very quiet. That was Aunt Lillian and we were to find out later that she was a Titanic survivor. I've always been intrigued by her story and decided to write about her this week. Lillian Thorpe was born in 1875. After her first husband died, at 28 Lillian remarried William Minahan, a wealthy physician from Wisconsin. They were married nine years before they took a trip to Ireland to visit his family. They boarded the Titanic for their return at Queenstown as first class passengers, along with William's sister, Daisy. The three occupied cabin C-78.

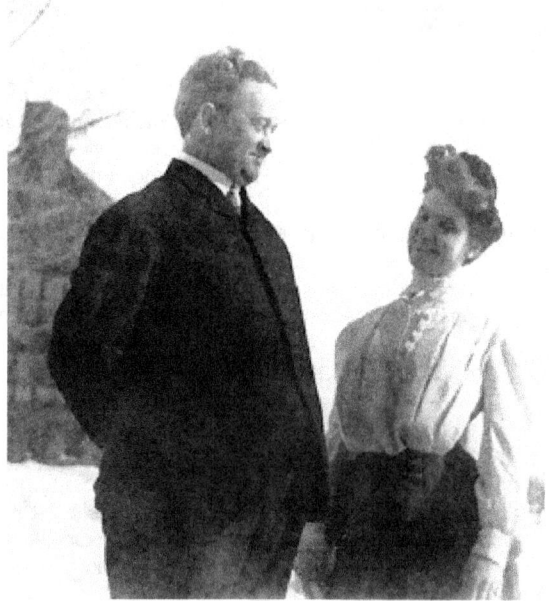

William and Lillian

When the ship started to sink, William put Lillian and Daisy in lifeboat #14. His last words to them was, "Be brave." For some reason, the two ladies were transferred to another boat (maybe their boat was overloaded), and then were later rescued by the S.S. Carpathia which eventually took them to New York where they were met by family members.

William's body was picked up by the CS Mackay-Bennett. Of the 306 bodies picked up by this ship, only 190 made it to Halifax and William's was one of them. The others were buried at sea.

Effects found on William's body:
Pocketbook; papers; gold watch, "Dr. W.E. Minahan"; keys; knife; fountain pen; clinical thermometer; memo book; tie pin; diamond ring; gold cuff link; nickel watch; comb; check book; American Express; $380; 1 collar button; £16 10s in gold; 14 shillings; nail clipper.

Can you imagine that Lillian, in her grief, had to write this letter?:

White Star Steamships
I hereby direct that you turn over to the bearer, V.I. Minahan, the body of my late husband, Dr. W.E. Minahan, and also all effects found thereon.
April 29, 1912
Mrs. Lillian Minahan

William's grave in Wisconsin

Daisy never recovered from the fateful trip. She died in 1919 at 40. Lillian, however, lived to the ripe old age of 86, married two more times and died in 1962.

The little cottages where we stayed are now gone, replaced by a big ugly apartment complex. But, I'll never forget the summer we stayed in Laguna Beach with Aunt Lillian, the brave Titanic survivor.

Nancy Javier - In the publishing business for the past few years. Author of 3 blogs - one on avocados, and 2 on film. Avid collector of old books and ephemera. Contributor to Sepia Saturday for the past 2 years. Resident of Fallbrook, California, the avocado capital of the world.

Nigel Aspdin : Notes And Queries

THE SPY WHO STAYED OUT IN THE COLD

I am sorry I have been away for the summer. I bought 3 packets of tomato seeds and got 33 seeds. With love and care each seed produced a beautiful plant, but the sheer attention to these plants has kept me in the garden and away from any blogging. Today as I write the clocks have gone back, a storm is brewing in the Atlantic, and the last tomato has to be picked. So maybe I will be back blogging soon....who knows?

It was hard to chose my favourite blog, so I just chose the one with the most comments, and it has some of my favourite sepia family photos. It also starts with the tones of the coming winter, and include some of my sillier ideas !!

I recognised him immediately. Being trained in observation from an early age as a Cub Scout was only part of it. What really made me jump was the connection with an inheritance from my grandmother, Granny Aspdin, (yes, the wife of my cycling bank clerk of a grandfather about whom I wrote last week). The inheritance is the only first edition book I have on my shelf, and were it not in less than mint condition I dare say it would be worth a bob or two.

My treasured first edition.
The book is very well known, and I will be surprised if I am the only one this week to have recognised Jerzy Fröwn, discretely standing there. His subtle choice of black on a snowy day is reflective of his early days training in the Czech navy, and quite possibly explains why he was fatally shot. [See 3rd line of page 2].

It was an unfortunate start to de-coding the message from Q his cell had received the day before, S370HSSV-0773H. He he never did realise he was reading it upside down.

But............ I know readers really want to know about my Granny Aspdin and English winters, so here she is in the 1930s in an era when we had genuine weather in Derby, and when water froze, those awful days before we finally succeeded in our quest to warm Earth sufficiently to stop us East-Midlanders having anything more than mud, fog and grey skies in winter.

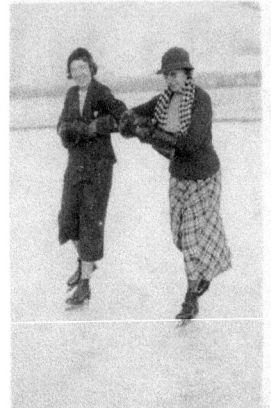

Left : The nee Slater girls, Granny-Evelyn Aspdin right and sister Beatrix Smith left. The Mundy Paddling Pool, Markeaton Park, Derby, circa 1930, and today, right.

Granny Aspdin had married my grandfather Bertie Aspdin in 1914.

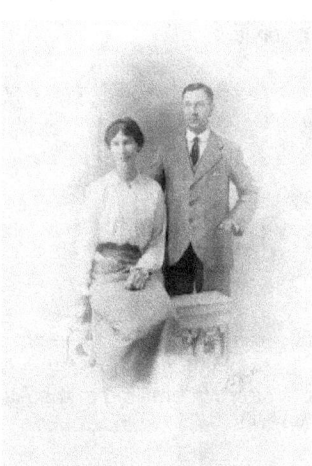 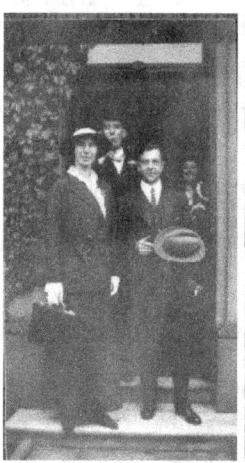

They must have had the wedding reception here at home, the family home where I now live, as photo evidence shows it did not entirely go without a hitch when they came to leave. Granny had a good life and lived into her 80s, but she always seemed jinxed on such occasions by unreliable transport. I remember that after the church funeral in 1966 all my family climbed into the big black limousine provided by the undertakers, only to find that the battery was flat. With my father telling me to get out and help push (I refused out of embarrassment as a 16 year old) all the mourners put their shoulders behind the limo' for a jump start. A smooth purr later from the Rolls Royce engine and off we went, following Granny in the hearse to the crematorium.

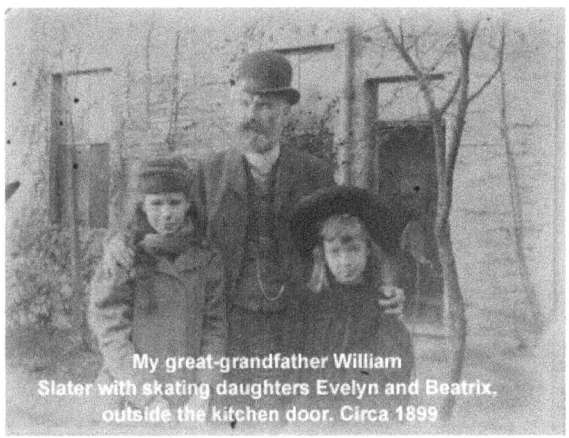

My great-grandfather William Slater with skating daughters Evelyn and Beatrix, outside the kitchen door. Circa 1899

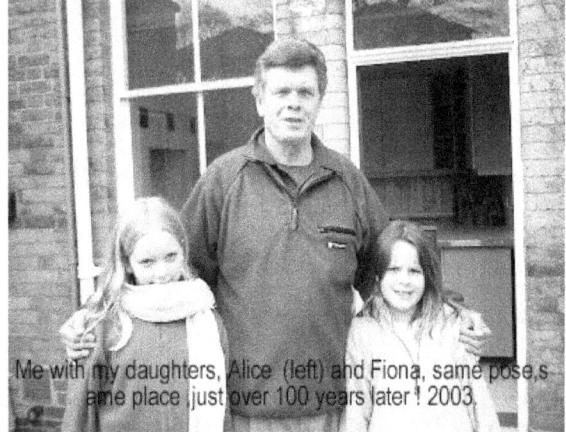

Me with my daughters, Alice (left) and Fiona, same pose, same place, just over 100 years later ! 2003

Oh!...its Alice's 20th birthday Tuesday, I think I will post this early, she's away at University and I need to send her a card, this post can be her card, that will save a couple of quid. Happy Birthday AL !! Love Daddy xxxxxxxxxxxxx

PS

I scanned an image from page 2 of the book for you.

Nigel Aspdin : Retired chartered accountant from Derby, UK, with as lovely wife and two lovely daughters both at university. Suffering from an obtuse sense of humour rarely understood by others.

Patricia Ball Morrison : Pat's Posts

FRANK OSTROWSKI

So here I sit at keyboard in Minnesota, USA looking back oh so fondly at how many years it has been since I first learned of and participated in Sepia posts. Sepia got me to blogging and researching my roots and afforded the way to use so many old photos. Now as we are celebrating our 200th week of Sepia posts, I have chosen my contribution from Week 13, February 27, 2010. Here with very slight updating is my Sepia Week 13 post about my great grandfather, Frank (Francis) Ostrowski.

Frank Ostrowski

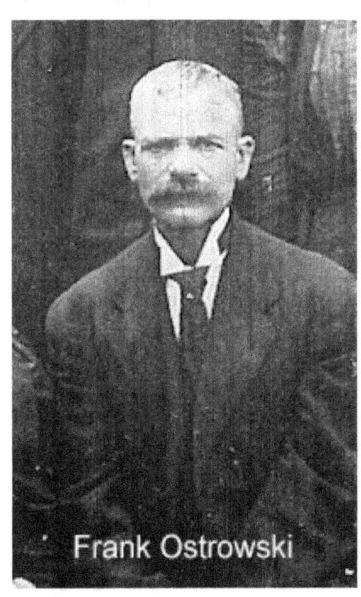

Frank Ostrowski is my maternal great grandfather who was a coal and sometimes iron ore miner in Poland, Prussia and in the United States. I knew my family was entirely Polish on all sides, (2013 note:but after submitting my DNA to Ancestry.com for analysis in 2012, I learned there is a very slight trace of Ireland or the British Isles as well, proof that the British Navy was everywhere in the world once. I have found no connection to that Brit ancestry yet, despite periodic Ancestry.com suggestions of 8th or so cousins however many times removed). However, I have learned a lot more since 2010 and my research indicates German, Prussian, and Polish heritage matching with my study of Poland's history that reveals how often it was invaded, conquered and annexed to another country. Those Poles are a hearty stock though and do not go down without a strong fight.

My grandmother and her sisters spoke Polish as did my mother and aunt; it was especially annoying to me as a child because I could not understand what they were saying. I know that was the reason they spoke it around me! But little by little I learned enough to eaves drop and discern the secrets. I discovered Frank in 1977 when my great aunt Francie gave me the photo of the Ostrowski (aka Ostroskie) gathering which I posted last week on Sepia Saturday. I spent most of my childhood with my grandmother, Rose, Frank's daughter from his second wife. How I wish I had known about him back then

51

and could have asked my Baba (babacis in Polish) about her father. She talked very little about her family or else I paid little attention, but said that her father died of stomach cancer as did several others in the family; she feared that and sadly she died of pancreatic cancer and diabetes; perhaps that was Frank's diagnosis too.

After Aunt Francie gave me the gathering photo she also found this snapshot of Frank in his miner's hat which I had copied and enlarged into a 5 x 7 Sepia print that has been prominently displayed in our home ever since. It is a good conversation piece. My grandmother's hand writing is on the back so at one time she had the photo but there is no date. I adore the old coal miner hat. Those were the most dangerous days of the mines and many Europeans flocked to the states to do the dangerous dirty work. My mother and aunt were of no help in verifying dates, saying that they never knew any grandparents but lots of aunts and uncles. Notice the clean shirt and the pick axe over his shoulder, arm crossed and holding hands with someone. Likely this was not what he wore into the mine, but there must have been some special occasion to pose. Someone really had to work at keeping that shirt clean and starched, back then, without today's automatic washers and dryers.

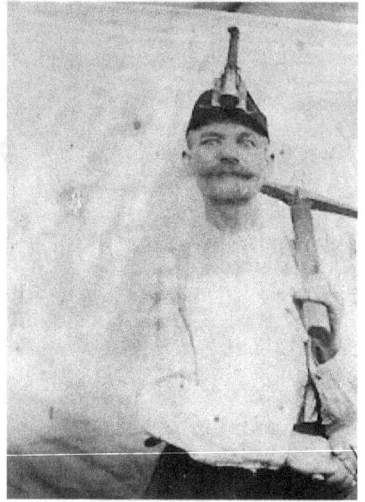

Frank Ostrowski my maternal great grandfather
Coal miner, pick axe, lantern hat and white shirt

Frank married three times and outlived two wives. By his photo he does not appear to be that handsome, but staunch, determined and I suppose an employed coal miner in America was a good catch for the times. If the historical fiction "A Coal Miner's Bride "by Susan Campbell Bartoletti has any truth, the old miners wanted a woman to care for them. Frank fathered many children so that would also account for his need to remarry when one wife passed on. I notice he has one eyelid that droops and my grandmother had the same affliction; I in 2013 notice the same has happened to my right eyelid so that ultimately I will have to have that "fixed" or lifted..

The spelling of the name Ostrowski changes depending on who recorded it, Ostrowski, Ostroski, Ostroskie, etc. I have two different years for his birth 1855 and 1857 and have been unable to confirm which is correct. However, the date of November 11 is certain making him my fellow Scorpio. Perhaps on our next trip to PA I can visit the Union cemetery in Arnold where he is buried and that may clarify date of his death. I should hope it will not add yet another date. (2013: Note several years ago we visited the Union cemetery; the office building was not open but there was a note on the door that if one wished to locate a grave submit a letter in writing and pay a fee of $15 or more and allow several months. We tried roaming and found some caretakers who directed us to the area known as Polish hill, far in the back, with few gravestones, quite over grown with shrubs, etc. No luck finding Frank's grave. I suppose one of these days I will send that letter and the fee and wait and wait. This is a strange thing as most older cemeteries are very helpful at no cost and willingly look in their records.)

Frank was born in Prussia, Poland or Germany to Franz Ostrowski and Katazinea (Kor Catherine) Biegonski. who likely immigrated to America with the children, but the records of when and where they arrived are sketchy. His sisters were Kate, Mary and Pauline who is recorded to have been born in Cleveland, and a brother Maryn John. It is possible that they came through Canada, but I have hit a block wall with that as well.

Information shows Franz was buried in Detroit, Michigan in 1893 and Catherine died in 1910 and is buried in Cleveland, Ohio. That date makes me wonder if the mystery Ostrowski photo taken in Ohio which I dated at about 1910 could have been for Frank's mother's funeral; perhaps confirming some of what my mother alluded to of a funeral in Ohio. While some of her research is flawed, I am grateful to my 2nd cousin who attempted to piece all this together with infrequent trips to PA. Maxine lives in Utah today is in poor health but as a member of the LDS church had access to many records. Still, I know she had some errors in the lineage and names and am skeptical of some of the information where dates show as "appx." Maxine spent some time interviewing my grandmother in the 1960's, but I know that my grandmother could be evasive as were many of the Polish. Whether they were untruthful to avoid attention or sometimes could not understand the questions, I cannot determine. I know that they feared and respected government authority and as immigrants escaping tyrants or worse in Poland, or the old country, they kept quiet about many things. Someone usually knew someone back in "the old country" though and kept in touch, frequently sending some cash along to help out.

Frank married his first wife Frances appx. 1877. Her last name is incorrectly recorded as my maternal grandfather's last name on the documents so I know that is wrong. She was born in Poland and died appx 1888 in PA. They had three children Joseph (born 1878 with a twin John who did not survive the birth), John (the second son to be so named born appx. 1882), and Benjamin Frank who was distinctly given the middle name (born 1883 appx.) Years ago Sharon, a cousin I had not previously known, granddaughter of Benjamin contacted me. When I asked my mother and aunt about this, they shrugged their shoulders. While they knew nothing about a grandfather they recalled their aunts and uncles and made no distinction of their being half brothers and sisters.

Frank's second wife who was my grandmother's mother was Frances Swartz (aka Schwartz) whom he married about 1889. Frances came from Poland, was born in 1869, died in 1902 in PA. Sometime during this marriage they dropped the "w" from Ostrowski off and on. They had five children although I recall my grandmother mentioning that some of her brothers died when very young; there is no record of others. These were Walter

(born 1889 in Detroit, MI who went by Bill and changed the family name to Austin), Mary (born 1891 in Salamanca New York), Veronica Bernice (born 1892 in PA), and Rose (my grandmother born 1894) and Adam Maryan who died at birth in 1899 or shortly thereafter. My grandmother said he was her mother's last child and did not live. I never referred to any of her sisters or brothers as "Great" they were all aunt and uncle to me; I called them the Polish word for aunt, "czotczhe".

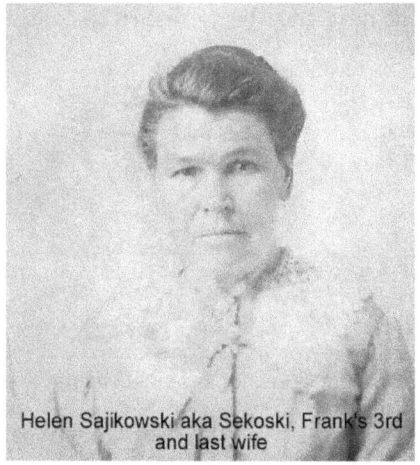

Helen Sajikowski aka Sekoski, Frank's 3rd and last wife

Frank married his third wife, Helen Sajowksi (aka Sekoski) in 1905. Their only child was Frances born in 1906 and was always known as the baby sister. Helen is seated next to Frank in the Ostrowski Ohio gathering, the photo I shared last week. Helen would survive Frank who died April 19, 1915 making him either 60 or 62 depending on which birth year is correct. My grandmother was fond of her step mother Helen and spoke well of her. Whether Frank fathered more than nine children is unknown but each wife seemed to give birth annually. How they traveled around from Michigan, to Ohio, to New York and to Pennsylvania is a mystery; I suspect it was by rail car. They certainly did not own vehicles to drive. Tracing the different places the Ostrowski's moved from Salamanca area of New York, Michigan and Ohio before settling in Pennsylvania, it appears Frank was following the mines in the heyday of coal mining; some how Pennsylvania must have offered him steady employment because he set roots there and his children did so as well. It was hard dirty work that the immigrants took on. Today, his descendants are all over the eastern United States, Pennsylvania, New York, New Jersey, and on to Michigan and Ohio into Newfoundland, Canada as well as some in California. All my years living in California I was never aware of any Ostrowski relatives there. (2013 note: A few years ago another contacted me from southern California where she still resides. They spell the last name Ostroskie). When I see the Ostrowski (Ostroski) name today I wonder if that is a shirt tail relation. Writing this piece I googled and found many; one example is Frank, a "falsely accused murderer in Canada" released on bail to his daughter.

Finally here is the last photo I have of Frank with his son, John. I found this in a drawer after my mother died in 2004. The back has the names and says "coalfield", but no date. My grandmother told that she learned to cook as a very young girl because her father was skinny but ate like a horse and said that her daughter, my aunt, Virginia took after him. Not all Frank's progeny were as lean as this photo where Frank is poking John's belly! John who was born in 1882 must be at least 20 years old here which would date this to 1902. I can only imagine what was being said. But there he is my great grandfather, Frank Ostrowski, I wish I could have known him or learned more when my grandmother was alive.

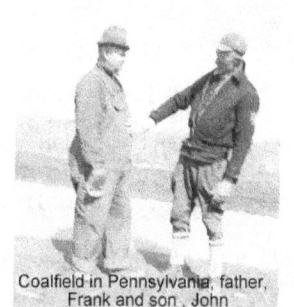

Coalfield in Pennsylvania, father, Frank and son, John

Patricia Ball Morrison : I am retired, from a 34 year career in state government, yikes a bureaucrat. Today I am a dabbler at many things writing, quilting, stitchery, reading, gardening, physical activity and living well in Minnesota, where we moved to hubby's home town in retirement...We snowbird in the winter and journey south to warmer climates in our motor home. Born and raised in Pennsylvania, but lived in northern California for over 40 years.

Peter Miebies : Peter's Blog

SEPIA SATURDAY – THE WATCHMAN

SEPIA SATURDAY 164 : 16 FEBRUARY 2013

When I saw the theme picture for this week I was very much surprised because I immediately recognized a member of the RSSSATP, you can tell by the protruding little fingers. As you can see he is closely watching a species of the Dermochelys coriacea. Beg your pardon, you don't know what RSSSATP stands for? That is the Royal Society for the Strategic Study of Advancing Turtles in the Pacific. Since you are apparently unaware of this important semi military organization, maybe I should explain their objectives. First of all I have to say it is a secret organization, a lot of hush hush. That is because of its strategic significance. Its membership is restricted to army and navy biologists and it is highly unusual to see a picture of a member in action.

You may wonder about the pipe. Well, so do I but my guess is that this officer is a pipe smoker. On the other hand I wouldn't be surprised if the pipe, or its smoke, is related to the study he is carrying out. Smoke curtains and all that. Because rumour has it that the research of this eminent organization has to do with amphibious

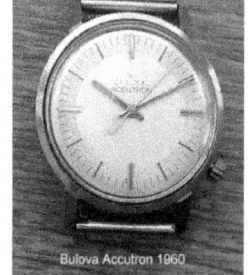

Bulova Accutron 1960

53

landings. You may know that certain turtles live in the sea but lay their eggs on the beach. The study aims at investigating the methods these turtles use to overcome the surf without capsizing. For this purpose certain marks have been applied to the turtle's shield. That is done to facilitate air reconnaissance. I am afraid I can't give you any further details without being accused of all kinds of nasty things.

Despite the risk of revealing state secrets I will base my Sepia Saturday contribution on the wristwatch the officer is wearing. Although I am not a wristwatch wearer (what a word!) myself, I do have a few heirlooms. To be honest some of these objects have not yet reached that status yet but one day they will.

This Swiss watch dates from 1960. It is a very special watch because the movement is determined by a tuning fork. Rather than giving you the wrong info I quote from Wikipedia. "The tuning fork movement was a horological revolution. Previously, electronically regulated timepieces were limited to some scientific instruments, being too large for a personal watch. The Accutron was also the first wristwatch precise enough to qualify for U.S. railroad certification." And if you qualify for the U.S. railroad...

You can see the tuning fork between the two electromagnetic coils at the top of the watch left. Unfortunately there is something wrong with my watch. When I activate the watch it runs way too fast. So if it has to become a valuable heirloom I need to have it repaired.

 The next timepiece is a pocket watch. It was given to me by my Aunt Jo. Aunt Jo was married to Johannes Frederikus Miebies (1899-1958), the son of my grandfather's brother and the previous owner of this watch. I tried to date this pocket watch by comparing it with Google images. But no success there. Fortunately most Omega pocket watches have been numbered. This one carries number 4322892. That means it has been manufactured in 1913. So this year it is exactly 100 years old! It is also Auntie Jo's birth year. Coincidence? I don't think so but I'll ask her, she's still among us! [Last month she celebrated her 100th birthday!]

Smiths English Clocks Ltd was operational between 1931 and 1979. I think this model was manufactured during the 50's but I am not sure. Apparently these 30 hours clockworks were a specialty of Smiths. I don't know why the clocks were limited to a 30 hours running time. There might very well be a technical reason for that.

Neither do I know when 30 Hour mechanisms were made. But no matter when that was, it's still running like you know what. It produces a nice ticking noise for easily more than 36 hours.

 My clock is integrated in the showcase like cabinet shown here. When we bought it the antique dealer said the cabinet was English made. For all I know it could have been Turkish as well. I am not an expert in these matters but possibly one of the Sepians is. The last watch on display here is another pocket watch. According to my mother it belonged to her father Gerardus Theodorus de Langen (1888-1967). It is a watch that puzzles me because I am not even certain in which country it has been made, Switzerland or France. It is a Judex montre de precision (precision watch) with serial number 997331.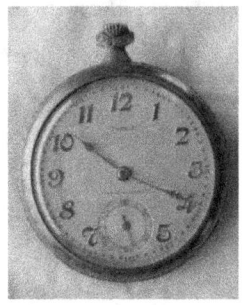

I saw another Judex pocket watch with a similar diamond shaped decor. That one was made between 1920-1930. Unlike the Omega shown above this one is running fine.

 When I opened the back of the watch there was another surprise: the original warranty. It mentions the serial number and the fact that the case is made of silver (argent). The term épreuve de réglage means 'test' or 'control'. But the nature of the test is not clear to me. I noted that the watch-glass has been replaced by plastic. At least I assume it has been replaced because I don't think plastic was used for the original. Maybe grandpa inadvertently dropped it somewhere.

Peter Miebies is a retired airline employee (KLM Royal Dutch Airlines) living in Castricum, The Netherlands. Since the early eighties he takes an interest in genealogy and writing. Also history is one of his favorite subjects. He is particularly keen on family and airline history. Furthermore he collects Dutch Leerdam and Maastricht glass. Peter has an English language blog (http://www.patmcast.blogspot.nl/) dedicated to all of his interests. He uses Twitter (@patmcast) to collect all kinds of information. Peter is happily married to Jeanne for almost half a century and looking forward to the other half.

POST OFFICE & RESTAURANT – CHANDLER, MINNESOTA

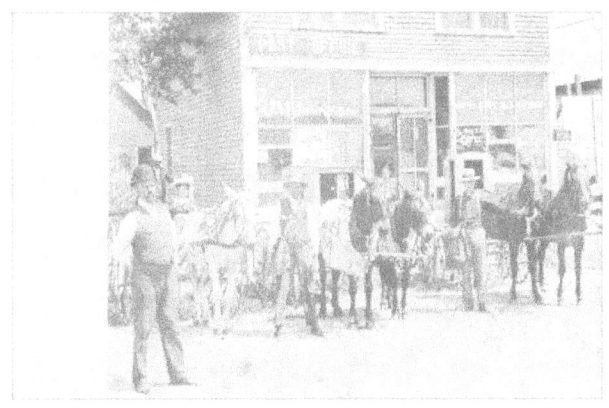

Above is a real photo postcard sent from Chandler, Minnesota in 1909. The postcard is rather faded looking, but through a bit of Photoshopping, I was able to get a much better view (below) of the details.

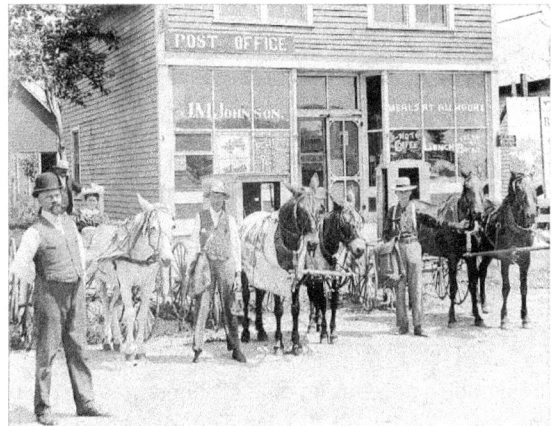

Chandler is a small town in the southwestern corner of Minnesota, with a 2010 population of about 270. According to the City of Chandler website, Chandler grew rapidly in the first decade of the 20th century and there were 30 businesses in 1906.

J. M. Johnson, whose name appears on the left window, was the postmaster at the time of this photo. He is the man in in the front. The two men with the mail bags are his mail carriers and their carts. (source: email from Murray County Museum)

Above is J. M. Johnson's name are advertisements for Northwest Thresher Engines and Separators, and Aermotor Windmill Pumps. A blanket with flour advertising is on one of the mules in the center of the photo. Minnesota was the top flour producing state in the country, with 400 flour and grist mills in 1901. I believe the name on the blanket is Ethan Allen Flour, a product of Wells Flour Milling Co., Wells, Minnesota. An ad for this flour is shown in Northwestern Miller, and the Minnesota Historical Society has an excellent photo of Ethan Allen Flour advertising on a horse here.

The signs on the right window advertise Meals at all Hours, Hot coffee, Lunch, and Fresh Bread. A small Telephone Station sign is attached to the right side of the building.

Postcardy is an avid postcard collector from Fridley, Minnesota. She enjoys blogging and maintaining personal websites about postcards.

Rietje de Jong (Prenter) : Boekerietje

THE MENDING WORKERS IN SCHEVENINGEN, NETHERLANDS

I'm going to tell you a story about the ladies on the wagon below. In Scheveningen they are called 'nettenboetsters'. I didn't find a translation, so I chose one myself 'mending workers'. If anyone knows better, please tell me!

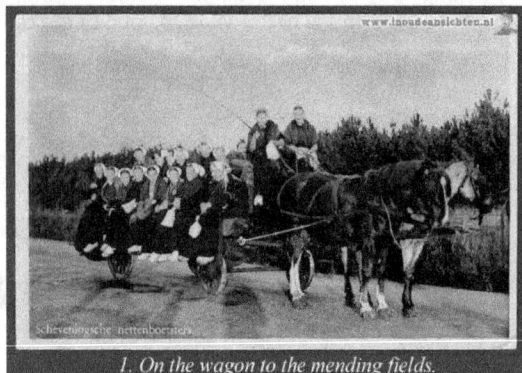
1. On the wagon to the mending fields.

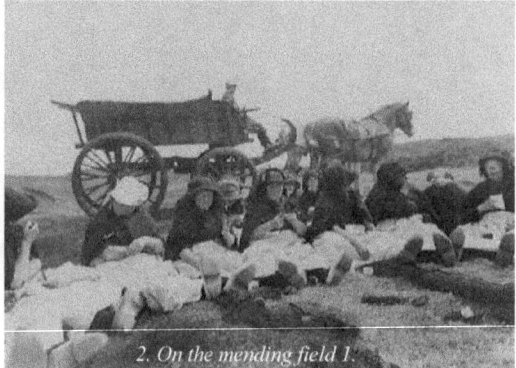
2. On the mending field 1.

The mending or repairing of the fishnets was an important link in the fishing business in Scheveningen. Once the fleet was in the harbor, the mending workers came into action to make the nets usable again for the next voyage. After each trip the nets were inspected and repaired. Should the nets quickly be checked then this could be done on the port side.

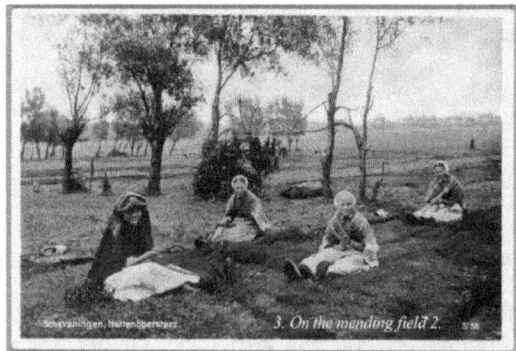
3. On the mending field 2.

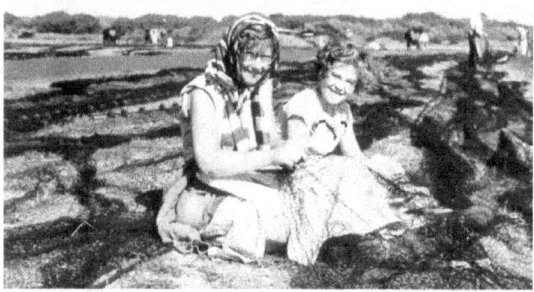
4. My Aunt and my sister on the mending field in 1958.

The repairing happened on the mending fields or in the attics of the shipowners by young girls and fisherwomen. Also former fishermen who wanted to earn some extra money did this work. It was not just young girls and women of sailors who checked and repaired the nets. The women of skippers and mates cooperated, but often as head women.

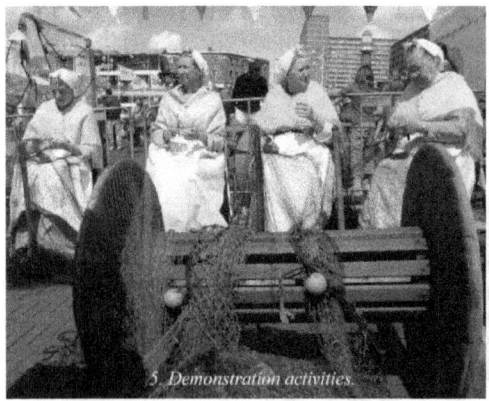
5. Demonstration activities.

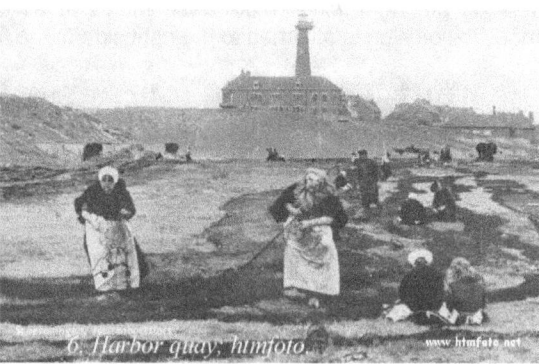
6. Harbor quay, htmfoto

Many women had other activities in addition to their role in the family, an additional income was nearly always a necessity. The repairing of nets was a hard job which was exerted by many women in Scheveningen. They often had to work long and irregular. If a herring lugger sailed inside on Saturday morning, he remained 2x 24 hours in the harbor before leaving again. The women worked until all the work was done, even though that was until Saturday night around eleven thirty. On Sunday, no one worked.

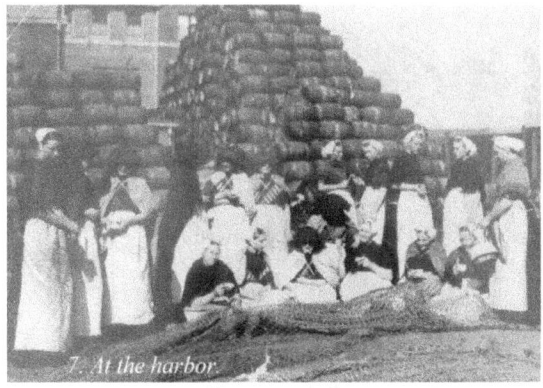
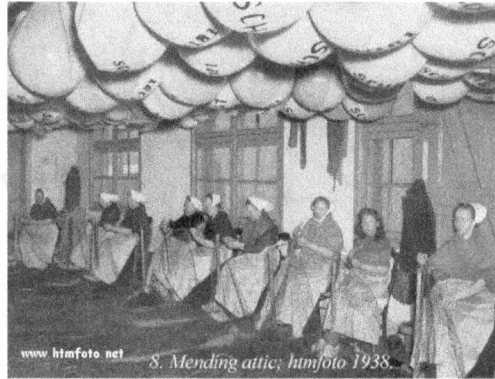

7. At the harbor. 8. Mending attic; htmfoto 1938.

In winter the women worked on the mending attics of the shipping companies. Once spring was well in sight, the various groups of mending workers went daily to the 'fields'. The nets to be repaired could be fully rolled out and the necessary work could be made much clearer. The women were then mending in the dunes and on the fields, nearby the water tower on the Harstenhoekweg.

During the activities on the attic the mending women not only worked hard, but they sang warmly. This were particularly devotional, spiritual songs. Twenty female voices echoed loudly through the attic space. All this was larded by long heard singing tones at the end of each line, as at that time was common during the singing of psalms at Scheveningen. Sailors or nets knitters, who occasionally also had to work in the attics, bravely sang with the choir in such circumstances. Perhaps that is why the fishing village still has several choirs, because it is beyond dispute: the inhabitants of Scheveningen love singing!

PS. The hanging white things hanging from the ceiling are not buoys, but balloons. The herring fishing was done with a 'vleetnet' of many kilometres length. This fishing net hangs in the water like a curtain and is being kept afloat with white balloons.

Sources:
Bal, C.: Scheveningen in oude ansichten, deel 1, 1987, blz 112.
Hoeken, Cees J. van: Schevenings goed, 1984, blz 30-35.
Noordervliet- Jol, Nel: Schevenings bezit, 2005, blz 159.
Slechte, C.H.: Scheveningen tussen twee wereldoorlogen, 1978, blz 70-72.
Spaans, Piet: Mooi-Tooi, 2001, blz 72-80.

Prenter : I live in the city Arnhem (Netherlands) nowadays, but I was born in a family of fishermen in the village Scheveningen at the shore.

Rose Theriault : Ramblin' Rose

SISTERS ON THE BEACH

This week, for Sepia Saturday, I have chosen some pictures of when my sister and I went to the beach and had a photo shoot. She was and still is such a good sport. She has since moved to Alberta and I miss her dearly. She is coming to visit this summer, perhaps we can have another afternoon at the beach.

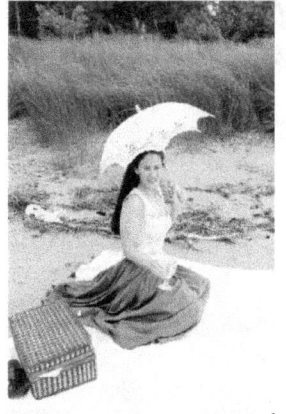
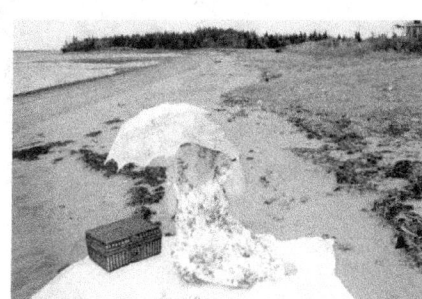

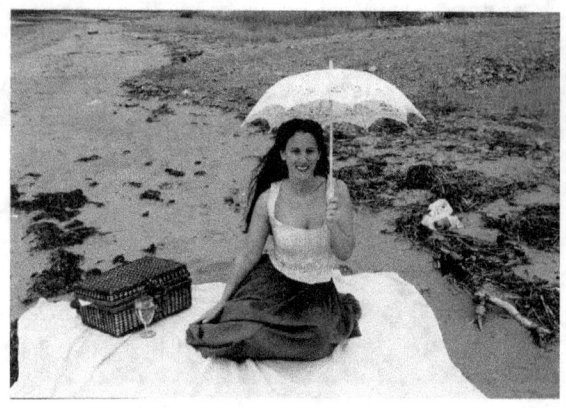
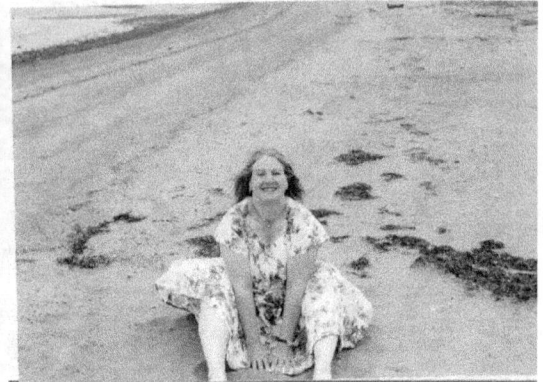

Rose Theriault, of Miramichi, New Brunswick, Canada is an amateur photographer who likes to take pictures of scenery, still life and some people some of the time. She mostly likes the ordinary of life.

Susan Donaldson (Scotsue) : Family History Fun

A STRETCHER BEARER IN THE FIELD

Fun, quirky, informative, nostalgic, poignant - all descriptions of so many Sepia Saturday challenges and contributions.

When I first saw this week's prompt, one of my previous posts immediately came to mind. It is one that I was proud to write and I valued the comments I received - what was it? The story of my Great Uncle George, a stretcher bearer in the First World War. He died at the Somme in 1916, a week after his 22nd birthday - and three weeks after he sent a letter home. It seems also particularly appropriate to feature it, as we near Remembrance Sunday. Here it is again, with some further images to complete the tribute.

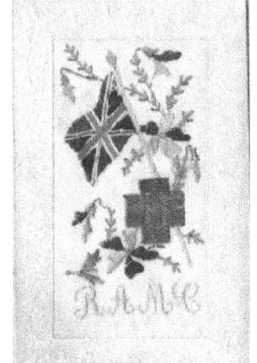

This week's prompt shows the kitchen of a hospital train in the First World War

"I had to assist the wounded at a dressing station and stuck to it for about 40 hours. It's blooming hard work being a stretcher bearer in the field."

These were the words of my great uncle George Danson, written three weeks before he was killed on the Somme.

One of the many embroidered cards sent from Flanders by her sons to my widowed great grandmother, Maria Danson, nee Rawcliffe.

George Danson was the youngest of eight sons (surviving infancy) of James Danson and Maria Rawcliffe of Poulton-le-Fylde, Lancashire. Born in 1894, he was followed three years later by the birth of an only daughter Jennie. The photographs and memorabilia here come from Jennie's collection.

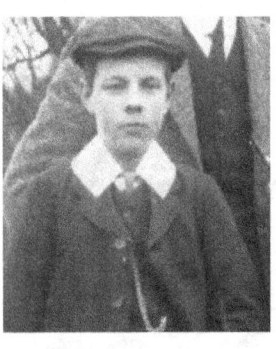

George (above) was the favourite uncle of my mother and aunt, and they had fond memories of him, perhaps because he was nearest to them in age and took on the role of the big brother. I can see why in the photograph of him above. George worked on W.H. Smith bookstalls at different railway stations in Lancashire and West Yorkshire.

George joined the Royal Army Medical Corps in 1916 and I was lucky enough to trace his service record on www.ancestry.co.uk as many were destroyed in the Second World War. On his enlistment, George's medical report stated he was 5'3" tall, weighed 109 lbs. (under 8 stone), with size 34 1/2 chest and he wore glasses - so a slight figure to be a stretcher bearer in the turmoil of war.

Also amongst the family papers were two letters written on headed paper of the British Expeditionary Force. A letter of 19th March 1916 to his eldest brother Robert said *"I will tell you one thing it is no easy job the army life today and I am of the opinion as most of the chaps are here they won't be sorry when it is all over."*

The second letter of 23rd August 1916 was to Frank, the brother nearest to him in age:

"At present we are about 8 miles behind the firing line. I had to assist the wounded at a dressing station and stuck to it for about 40 hours. It's blooming hard work being a stretcher bearer in the field. On Friday I was in a big bombardment and will say it was like a continual thunder and lightening going off. As I write there are blooming big guns going off abut 50 yards away every few minutes. Don't I wish that all of us could get home. Wouldn't that be great, lad, there's a good time coming and I hope we shall all be there to join in."

Three weeks later, and a week after his 22nd birthday, George was killed on 16th September 1916 at the Battle of the Somme, and buried in the Guards Cemetery, Les Boeufs, near Albert.

A photograph, sent to his mother, of George's grave. It conveys in a stark way the reality of war amid the mud and blood that George must have experienced - and contrasts with the pristine white of the more lasting memorials that we recognise today.

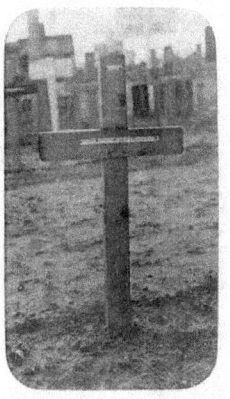

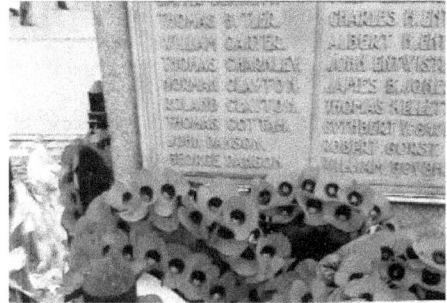

George remembered on Poulton War Memorial along with his brother John who died in 1917.

ScotSue is Susan Donaldson from the beautiful Scottish Borders. She is a retired librarian with a varied career that has included work in tourist information centres, and local studies archives. Family history interests span her own family from Lancashire and Shropshire in England and her husband's maritime ancestors from Leith (Edinburgh) and South Shields in Tyne & Wear. Her other interests (besides family history and blogging) include classical music, photography and crafts.

Sean Bentley : Eff-Stop Local – Small Radius Travel

X MARKS THE SPOT

A while back I posted a series of Sepia Saturdays based around my discovery of my great-great-grandfather David Blumenfeld's memoirs, which concerned his childhood in Eastern Europe, as well as his immigration to the U.S. in 1884 and subsequent travails. In August 2012, I and my cousins traveled to his home town of Tukums, Latvia, both to continue our research and get first-hand experience of walking where he had. Following is a summary of that trip, illustrated by old postcards of the Tukums town square, which figures prominently in the opening of his story:

"One bright spring morning when the sun was benevolently smiling on all nature, Leah was sitting on the veranda of her two-story dwelling overlooking the great 'Parade Platz' market place, in her native town of Tuckums, Courland."

The following is excerpted from my essay that just appeared 10/7/12) in Poetica Magazine.

This day in August 2012, I am one of a handful of David Blumenfeld's descendants exploring the streets of Tukums. Through the "Diary," we cousins have spent the last four years getting to know each other and our shared history, and Fred and Deborah have been critical interpreters in my belated proper introduction to Jewish culture. Their side of the family remained in the Midwest and clove to tradition. Mine left their families behind to pursue a new life amid strangers on the West Coast. I now know this was — for my mother, at least — a logical follow-up to the peregrinations of her father, grandfather, and great-grandfather — peddlers all, of one sort or another. But what her grandparents left behind, and why, why her own mother fell (or jumped) from the Jewish tradition, who we really were — some of these answers have assembled themselves from the Diary. Others we knew we'd have to come to Tukums to unravel, this ancient town on one side of the ocean and the vast new world on the other –cross from present to past.

Having pored over the Diary, trawled the pages of censuses and lists of the murdered, questioned our mothers and uncles, flown the miles and hours, and at last having paced the smooth swirls of gray cobble in Brivibas Platz – Liberty Square – and seen the walls our ancestors saw every day – having set foot in the garish gymnasium that was their synagogue – I am beginning to see the ghosts of the Blumenfelds. We are finally beginning to materialize, them and us.

The Klatsovs' Store, c. 1890

And we must not forget the heretofore mysterious in-laws the Klatsovs. Up until 2010 I'd thought (as did my own grandmother) that my David Blumenfeld's mother's maiden name was Gottshalk. But there were no Gottshalks in Tukums. However, the death certificate I finally found showed her father's name as Klashoff, and although Tukums had no Klashoffs either, it did have Klatsovs, and furthermore they all had the correct first names and birthdates. Thank you, Internet. And today we stand before a large, modern (which is to say nondescript) bank on the spot where the squat, tile-roofed, family store sat for decades. Where did the Klatsovs go?

My cousin Bob notes later that we are "looking for roots, in a place that saw two totalitarian empires engage in a ruthless extirpation of roots." And it's true, much of what we come across in Latvia consists of absence. Starting with the Jews, of course, whole towns-worth of human beings obliterated. And now even the buildings gone, sites replaced, repurposed, disguised as libraries and basketball courts, or long demolished and replaced by a bank. The Jewish cemetery on the edge of town is hidden and barely accessible through stands of wild bushes and dry grass tall enough to hide the effaced and lichen-etched stones; the bloodcurdling crescendo of a dog-pack's snarls echoes through the pines from what I am glad turns out to be the local off-leash park.

The Gone. Gardens and squares bear statues and busts of the dead and the heroic amid the tidy flowerbeds – in homage to humanity, to complement nature (both marble and flower are well-artificed, asserting our stubborn will to instill beauty as well as dignity amid the desolation). Outside of town, the countryside is studded with abandoned factories and never-completed apartments from the Soviet era. But in the surrounding farmlets, the narrow alleys of Tukums, it is the humblest of abodes that most often remain in daily use – the People endure when Empire has shattered. Except, that is, for the Jews.

Holocaust memorials (almost grudging — small, subtly plaqued, and out of the way) are offset by the odd spraypainted swastika on an inconspicuous wall, a secret small and dirty but alive in the shadows. There are the museums with their token rooms of Jewish Remembrance, the blurred monochrome news-shots, twisted spectacles, shirt buttons torn off and battered, yellow cloth stars and fragments of barbwire — but these are overbalanced by the lavish displays of Stalin's deportations of the Latvian survivors – the Jews simply swept into virtual nonexistence by Hitler beforehand. (Townspeople had chipped in with that, too, both

Klatsovs' store on far right, c. 1925

to try to save their own skins and in retaliation for past grievances. The German landowners had employed Jewish overseers, and both lorded it over the native Latvians. The country was batted for generations between Russians and Germans...the vagaries of power and dogma pounding like floods of mud over the weaker territories, the "lesser races."

So where are our Klatsovs? At the Jewish Museum in nearby Riga I was stunned to discover the names of both our great-great-grandfathers in the index of a fat book on historical properties in Tukums. There were grainy photos of these buildings through the ages, along with descriptions of the history of ownership. We noted the addresses and drew circles on our maps. We hoped to touch history.

But houses here, even shops in full swing, show generations of modest rejuvenation – layers of plaster over worn planks, paint over chipped plaster, new paint over old, color over color, like aged and grimy bandages barely binding shattered and tilting skeletons. As with the architecture, so with our lives. Here then is the house where our great-great-great-grandfather Jossel Blumenfeld lived – well, the spot where his house once stood, anyway – indeed an old house but not old enough, despite its tilt, its dust and tattered blinds – built only in 1924 long after his death. Someone lives here now, someone unrelated. To us, and perhaps to the past at all. Someone who in all probability knows nothing of this house's ghost — or of the whole town's ghosts, since decades of shame and horror have omitted the Jews from the local education, and there are so few left here that even the alive and well exist almost subliminally. This small brown house sits in the space where Ben Zion Blumenfeld grew up with his father, was drafted into the Russian army, around the corner from the square where he was drilled, and the synagogue — in which now kids play basketball – where he met his wife-to-be. Leah was daughter of prominent shop- and property-owner Yankel Klatsov, who raised a family of girls and a favored son, David; David would inherit the family fortune, stay in his home town, raise his own family of girls and a son, and feel no need to take the desperate and perhaps foolish chance that his luckless brother-in-law Ben Zion took (after an almost comical series of business failures) by moving his family lock, stock, samovar, and featherbed to a new country where neither German, Russian, Latvian, Hebrew, nor even Yiddish was a common tongue, where chances were that success would be equally hard to find, but where at least his sons would be safe from the Czar's army. In Tukums, David Klatsov saw no reason to move. He thrived. He did not fear the future.

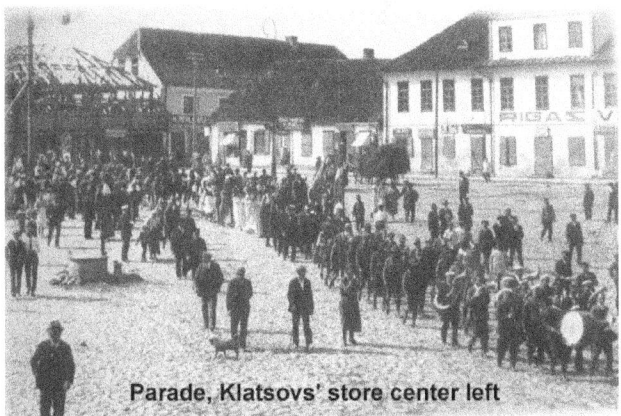

Parade, Klatsovs' store center left

Cousin Fred, learning that the shop that sat calmly at the center of Tukums picture postcards for a hundred years had passed on to David Klatzov before The War, on a hunch looks him up on the Yad Vashem website. Typing the name is like the midnight phone call, the pounding on the door: Slaughtered by Nazis, aged 86, July 1941, with son Mordecai. As well as hundreds of other Tukums Jews. This then, we clarify to the museum director during our visit, is why the store closed one day and never reopened, why it sat vacant for years and then fell to the wrecking ball. The owner disappeared one day and never returned. Not because he had gone to America to find his fortune: because he hadn't thought he needed to.

En route to Tukums we drove through fields speckled with tall storks as in a fairytale, white with black wings, legs and beak blood-red, perched on thickety nests atop telephone poles and barns. But like we've found by walking our family story down these time-soaked streets, the stories are true — these aloof creatures truly have flown from Africa, to nest… They really follow the ploughs across the wheat fields hunting voles, frogs, crickets turned up by the blades. A symbol of luck, it's said, but to whom? They didn't bring luck to the Tukums Jews, the Riga Jews, or the Jews of Kaunas, Lithuania, where we will head next. They are rather a parable — of hope, of the freedom

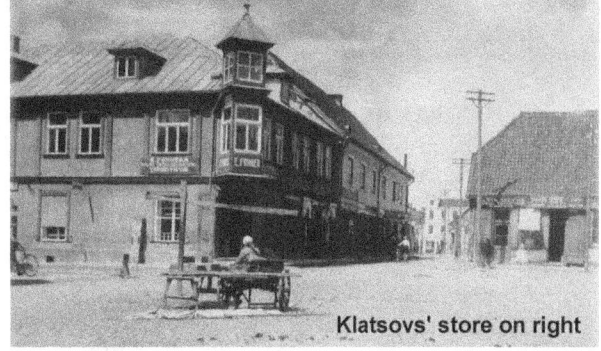

Klatsovs' store on right

to raise one's children and risk journeying as far as necessary to do so…. Perhaps the stork could be the symbol on the Blumenfeld crest. If there were one. This is where, this is how I begin to solidify my heritage, not so much "find myself" as place myself — yes, nailing the family story for accuracy's sake, for my own children, but confirming that it's more than just apocrypha. Tukums' swirling cobbles serve as the hard evidence, as small gravestones our names are now etched into. We follow the plough of history, free for now, and hunting our sustenance from what has been left to us.

Postscript, October 2013:

Soon after returning home, armed with the Klatsov information, I stumbled upon a family tree (surname Behr) on the Internet which gave some further names and connected a few more dots. Soon my cousin Fred and I had uncovered a trail of direct Klatsov descendents from Tukums to Palestine in 1925, and thence to America, most of them neatly avoiding the Holocaust. One exception was Julius Drabkin (1918-2003), one of David Klatsov's grandsons, whose harrowing story has been recorded -- and you can read the transcript at this link -- for the The Bay Area Holocaust Oral History Project.

Amazingly, there was a large contingent in Southern California, practically in Fred's back yard, whom he had never known about. Since then, they all have had a reunion - many of the California cousins hadn't met each other in decades, and of course none knew there was another line of descendants in the States.

Fred also traveled to Israel and met the other contingent, who were equally amazed and delighted to find more surviving descendants. They were able to provide a few precious photographs, some of which follow.

Devora (1877-1972), the daughter of David Klatsov, moved to Tel Aviv in 1925 wit her husband Zvi Traub

Devora's sister Sarah Klatsov and her husband Mischa Drabkin perished in Riga in 1941. Their son barely made it through the war, and eventually moved to the US with his family.

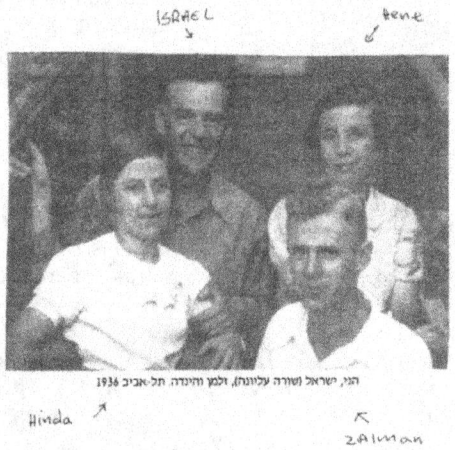

The children of Devora Klatsov Traub (with stepson Israel Traub): Hene 1898-1990, Hinda 1908 - 1993, Zalman 1913-1984.

Sean Bentley was born in Seattle rather a long time ago. A recovering poet and power-pop guitarist, he is currently a technical writer/editor, obsessive genealogist, and eccentric flaneur with a Canon.

Sharon Fritz : Strong Foundations

AHS WANGANELLA

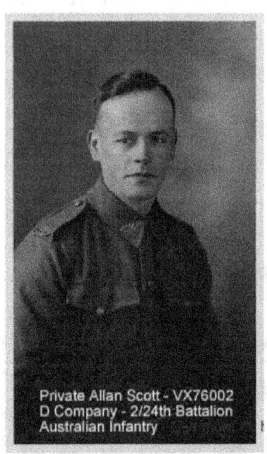

Not long now. Excitement. Nervousness. Trepidation. Relief. Joy. The air was electric with anticipation. Beaming smiles abounded, even on the most hardened faces.

After so long abroad, we were nearly home. Land was in sight. How I had dreamt of this moment. My heart ached and raced to see my dearest Eva. I hope she could bring the nips to see me.

But then there was a moment of doubt. Had I changed too much? In getting the job done, I had seen things and done things that she should never know about.

I looked around at the smiling men, lining the deck and my fears disappeared. The sun was shining. I had made it home. Very soon my arms would be around my sweetheart. Life is Good.

This is how I imagine that my grandfather felt as the Australian Hospital Ship, Wanganella, approached Melbourne in March 1943.

This photo was in my grandmothers photo album and was labelled;
"The hospital ship that Allan came home from the Middle East on 1st April 1943"
A search of Australian hospital ships on the internet soon revealed that this ship was the Wanganella as it is easily identified by the number 45 on the bow and stern.

Wanganella To Be Hospital Ship

MELBOURNE, May 28.
The Wanganella, interstate passenger motorship belonging to Huddart, Parker, Ltd., has been taken over by the Commonwealth and is being converted into a hospital ship at an Australian port.
Built in 1932, she is of 9,576 tons. Until six months ago she was on the New Zealand run. Since then she has been on the Sydney-Fremantle service.

The Advertiser (Adelaide) 29 May 1941
Source: www.trove.nla.gov.au

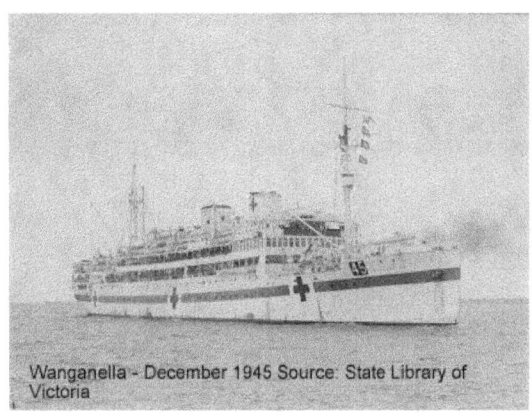

Wanganella - December 1945 Source: State Library of Victoria

My grandfather, Allan Scott, contracted Rheumatic fever whilst on active service in the Middle East. He was evacuated on the 6th February 1943. He wrote a letter to my grandmother while onboard the Wanganella.

" 19th March 1943
Dear Eva,
Well just a line to let you know I am still in the land of the living, in fact I am feeling very well again now and will be seeing you in about a fortnights time. I lost a lot of weight while in hospital but am putting it on again now & I should be too as I have an enormous appetite at present. I think it must be the change back to Aussie rations. I am having a bit of a struggle to write this as the boat is pitching about considerably & I am just sitting on the side of the bed with the pad on my knee. We are on a hospital ship that carries between five and six hundred when fully loaded but there is only 180 on this trip as we are the last of our lot to return. One thing we have plenty of room & the staff have a pretty good time as well & they look after us extra well too. Most of us are feeling pretty right & there isn't many bed patients.
You will be notified a couple of days before we arrive & I believe they give you a free rail pass to come & meet us & don't go thinking I am bad just because I am on this boat because I am quite well. I will get this posted airmail from Perth & hope you get it before you come to the city. You had better wire Wally (his brother) & get him to meet you at Spencer St or you may have some trouble finding your way about. His address is 2 Coburg Street, Coburg in case you don't know it.
I think we get away very soon after leaving the boat & I believe we get 14 days leave for a start & probably some more after but am not certain of that. The 14 days is convalescent leave. If your pass is good for a few days you might like to have a look around the city while you are there. I think I will send a wire from Perth too in case you don't get this before you leave to meet me. We expect to get to Perth about next Thursday or Friday & to Melbourne about six days later. We have run into quite a few rain storms in the last few days. It is very hot too. We crossed the equator about 4 o'clock yesterday morning so it will get gradually cooler from now on.
I wish you could bring the nips to meet me too but I don't spose you would be able to as Don will be going to school & besides you would have to bring too much baggage. I will have a fair bit of stuff to carry too. Tho I will be wearing quite a bit more than at present as I am only wearing a pair of shorts & just put a pair of canvas shoes on to get up on deck. I play a fair bit of deck quoits during the day and five hundred at night & spend the rest of the time sun bathing, reading or sleeping. Well dear I think I will stop now & write to a few of the others between here and Perth & will most likely write a bit more to this in the mean time so for the present I say cheerio & will be seeing you soon.

25th March 1943
Well we are just about to Freemantle now, expect to pull in sometime this morning so another week & I will be seeing you I hope. I don't know if we are going to get ashore for a while or not so may not send the wire I mentioned earlier. I can get one of the chaps that are going off here to post this. We are still having a good trip. It will take us about five to six days from when we leave Freemantle to get to Melbourne. Well now old dear I must stop as its nearly breaker time so cheerio with all my love to you all now and forever. Allan"

MIDDLE EAST WOUNDED ARRIVE

A hospital ship with the last party of wounded members of the 9th Division to leave the Middle East has arrived in Australia. The majority of the men are now convalescing from their wounds or illness.

Evidently the trip was not as totally uneventful as my grandfather's letter as he later told his family that the hospital ship needed to turn quickly and change course to avoid a Japanese torpedo boat that was in their path.

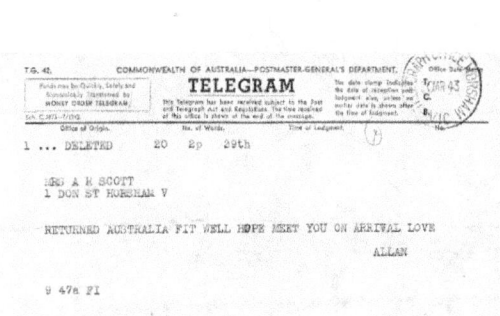

Received by Allan Scott the day he returned to Australia in 1943. It was discovered among my grandmothers papers after she died in 2006.

My grandmother, Eva Scott, wrote more than 50 years after my grandfather returned from WWII;

"Allan's regiment were sent as reinforcements to El Alamein where the fighting was pretty fierce, but all over before they got there – thank goodness. So they were sent home on leave, but he did not come. I wrote to the headquarters Melbourne – asking why. Got a registered letter, which I didn't keep (wish now I had). It said he developed hepatitis and asthma and was on his way to Heidelberg Military hospital and they would let me know when he arrived by hospital ship – which they did –and asked me to keep it under my hat. As soon as I got word I went down. Wally was stationed at Bourke St so I made for there thinking he would be there, but red tape kept them at Barracks which Mavis knew so she took me there. Barry was only 6 weeks old, so I carried him for Mavis and one cheeky devil of a soldier said quite loud – "Where did you get that baby"? From then on he spent quite a bit of time at Heidelberg – they made him TPI".

My grandmother was mistaken in her writings as the army records indicate that my grandfather contracted Rheumatic Fever not Hepatitis as she states.

My grandfather was still in the hospital at Heidelberg in July 1943 as I also have a letter written to my grandmother, dated 8th July 1943 from "Ward 18, 115th AGH Heidelberg". The Defense records indicate that he was made TPI and discharged on 30th November 1943.

My grandfather, Allan Scott, died 6th April 1965 at age 56, as a result of an "acute cardiac arrest" as a result of long term "chronic rheumatic valvular disease of heart", which would have been a result of the rheumatic fever that he contracted whilst serving in the Middle East.

HEIDELBERG MILITARY HOSPITAL

With accommodation for 272 beds in four pavilion blocks the first section of the Heidelberg Military Hospital will be formally opened by Mr. Spender, Army Minister, at 3 p.m. on March 15.

The hospital, when completed, will have a capacity of 1,500 beds, and will be the largest in Victoria. The pavilion section, containing 1,000 beds, is now almost completed.

Separate buildings are being erected for staff, administration, and special departments.

Sharon believes that it is important to record memories, events and details of our heritage for future generations, before it is too late and lost forever. It is her dream to retire early and spend her retirement travelling around Australia and overseas, visiting relatives, taking photos and researching her family history.

David M Lynch (Silver Fox) : The Lair Of The Silver Fox

TECHNOLOGY – A SEPIA SATURDAY POST

This is the 200th anniversary of Sepia Saturday! I've participated off and on during the past four years, and didn't want to miss being part of its special week. Therefore, in accordance with this week's guidelines, I'm reprinting my favorite Sepia Saturday post, from March 26th, 2011. This and most (if not all) of this week's other Sepia Saturday entries will be published in a book called -- appropriately enough -- The Best of Sepia Saturday.

Every parent, so they say, dreams that his or her child (or children) will have a better life than the parent had. A better education, better financial status, a better marriage (if that applies), etc.

There were more technological advances during the span of my mother's life than I could list, even in a post of my usual entry's length. And say what you will about some of the downsides of "progress," we certainly have it easier in many more ways than those who lived in 1917, when my mother was born.

My mom lived to see high-definition, flat-screen televisions. When she was born, radio hadn't even entered its golden age. Commercial air travel hadn't even gotten off the ground... errr... so to speak. And I could go on.

Even during my own childhood, computers were enormous monstrosities that filled half a room. Using one of those babies as a "laptop" would crush you to death.

Now, of course, we have "personal computers." And we have eBay.

Thanks to eBay, I now own something my own mother never got to own (due to its expense), but should have: Her high school yearbook, from 1935!

Northern Lights was the name of the yearbooks issued by North High School in Worcester, Massachusetts (during the 1930s, anyway). I recently purchased one at a relatively modest sum from an eBay dealer. The copy I own was originally the property of Alice I. Maki, an attractive blonde whom I can only assume is no longer with us... like my mom.

Upon receiving it, I read the thing cover to cover before leaving the post office lobby, looking for my mother's main yearbook entry, and any other listings, photos, etc. of my

mom's senior year. There weren't many. I'm sure her chores at home kept her from being a social butterfly.

But I did expect at least one or two music-related activities, and I wasn't disappointed.

It didn't take me long to spot my mom's photo among the many students shown above.

It would have been nice if I'd thought to look for this a few years ago, when my mom was not only alive, but when her vision was still good enough for her to appreciate such a find. At least I have the comfort of knowing that it's not something I thought of and then characteristically put off doing until it was too late. That would bother me.

Before I even received my package, it occurred to me that, even if she had never owned one herself, my mom might have autographed Alice's copy. And I was right!

That was a nice touch. Almost like a brief note from my mom to her son and daughter, which "only" waited 75 years before we got to see it.

Gotta love eBay. Thanks for your time.

David M. Lynch, a/k/a The Silver Fox, delivers an occasional blog post, short story, poem, song, or article from his home in Southern Massachusetts, USA.

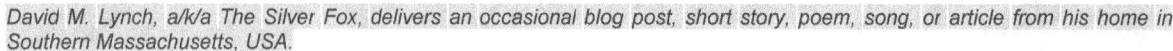

Tattered And Lost : Vernacular Photography

SEAPLANES TAKE FLIGHT

In honor of Sepia Saturdays 200th post anniversary I am reposting this from April 14, 2012. From what I've been able to figure out I first posted on Sepia Saturday in 2010. I have not been a consistent regular, and when I'm away from it I do miss it.

A plethora of flight images for this week's Sepia Saturday.

In the late 1940s and during the Korean War my father flew seaplanes as a Naval aviator.

These first shots in black and white were taken in San Diego of a PBM utilizing JATO packs for take off. You can see the JATO rockets on the side of the plane. There were two on each side and a pilot could activate one on each side or all four at once. JATO stands for jet-fuel assisted take off. Click here to read about JATO.
The Martin PBM Mariner was a patrol bomber flying boat of World War II and the early Cold War period. It was designed to complement the Consolidated PBY Catalina in service. A total of 1,366 were built, with the first example flying on 18 February 1939 and the type entering service in September 1940. (SOURCE: Wikipedia)

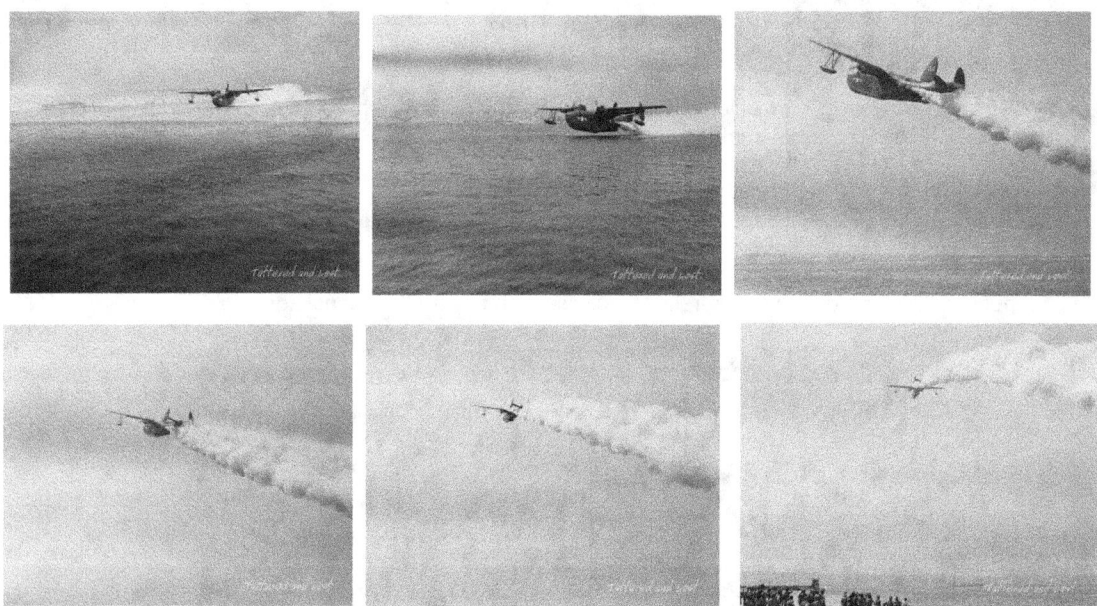

You can see the JATO packs in this next shot.

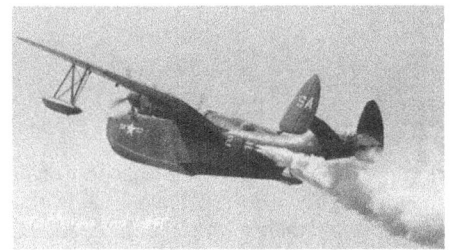

The second group of shots are of P5M's in Iwokuni, Japan. I have no idea who any of the people are.

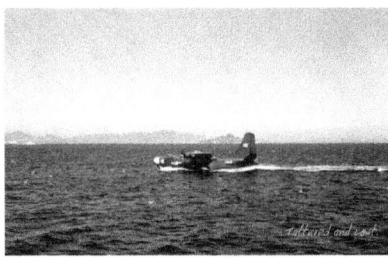 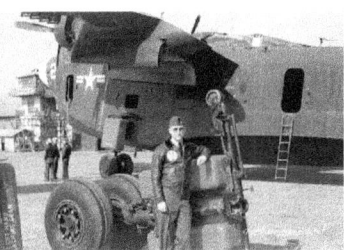 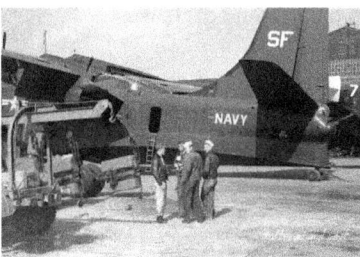

The Martin P5M Marlin (P-5 Marlin after 1962), built by the Glenn L. Martin Company of Middle River, Maryland, was a twin-engined piston-powered flying boat entering service in 1951 and serving into late 1960s in service with the United States Navy for naval patrol. It also served in the U.S. Coast Guard and with the French Navy. 285 were produced overall. (SOURCE: Wikipedia)

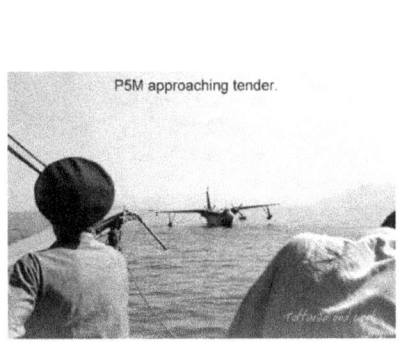 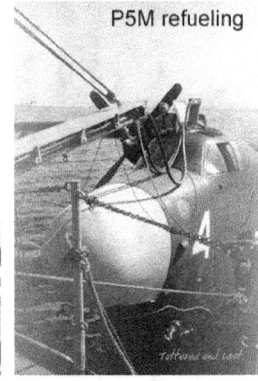

During the Second World War, both the American and the Japanese Navies built a number of seaplane tenders to supplement their aircraft carrier fleets. However, these ships often had their catapults removed, and were used as support vessels that operated seaplanes from harbours rather than in a seaway. These aircraft were generally for long range reconnaissance patrols. The tenders allowed the aircraft to be rapidly deployed to new bases because their runways did not have to be constructed, and support facilities were mobile much like supply ships for submarines or destroyers.

The German navy in World War II did not operate any seaplane tenders. However, the German air force, Luftwaffe, had 19 seaplane tenders of both large and small sizes in operation. These ships were mostly converted from existing civilian seaplane tenders, and were capable of carrying 1-3 seaplanes. The French and Italian navies also had seaplane tenders in service.

Seaplane tenders became obsolete at the end of the Second World War. A few remained in service after the war but by the late-1950s most had been scrapped or converted to other uses such as helicopter repair ships. (SOURCE: Wikipedia)
To see another post about a P5M click here.

Over the years I've heard my father tell a lot of seaplane stories; one event during the Korean War in which only two planes took part is even mentioned in a book. The only one of his planes I was ever on was a P5M. I was a little girl and it was a huge plane. A vivid memory I'll have forever.

Tattered And Lost : I am a book designer who lives in Northern California with a love of old photos. I, along with the images I collect, am tattered and lost.

Tony Zimnoch

HOW TO HATE THE WORKING CLASSES

This week's Sepia Saturday see's the 200th week of posting. To mark the event, we have been asked to select our own favourite post. Of my own posts I have chosen Sepia Saturday #102 "How To Hate The Working Classes" (Friday, November 25, 2011). It looked at some photos I found of local Halifax characters; "eccentrics'; gentlemen of the road; kerouac's with Yorkshire accents..call 'em what you wish too. I knew of both these gents in my childhood. I used to pretend on Sunday mornings aged 11 to go 9 o'clock Catholic Mass on my own. Unknown to my parents, I went instead to People's Park in Halifax. Often I used to hangout for half an hour, with this other brand of Saints.

Our first man is Tommy Cheesbits (outside a 1970's shop. I'm on theme by accident this week!). Tommy was one of those "characters" who, in retrospect, are remembered by a community. "You dont get any characters these days" people say. I'm not so sure if thats true? Maybe we only recognise 'character' in retrospect?
I remember 2 other local characters from my youth in the 60's..70's.....80's...[hey! I had a long youth!]. Sadly I dont have any photos of them. One was a guy who dressed up as a Roundhead Soldier..& used to ride around The Pennine Moors on his horse. I know not why. I remember once, driving along Blackstone Edge in thick fog..and suddenly he appeared silently (from shrubs & grassland) like an extra from The Twilight Zone.
Another chap I remember was someone who seemed to spend his life walking up & down The Calder Valley. Dressed as a monk..., in bare feet.

Donald John

A famous face in Halifax, Donald John was in the navy but allegedly turned to 'a man of the road' after he returned to find his wife had betrayed him. He is described by many as a pleasant man who enjoyed a drink.

> *I loved this guy, i used to tell him where there was any scrap, visited him in hospital when he had throat cancer, I also attended his funeral which was very well attended, I think he was one of the last of the Cowburn totters, I miss the old characters of hx, when Donald died the Courier ran weeks of eulogies about him. Donald John R.I.P............[Ken]*
>
> *............ he used to go to Butterly Bricks in Elland every night my grandad kiln man there and my grandad used to let him sleep near kiln where it was warm........[Karl Gledhill]*
>
> *Ken was telling me recently about another Halifax character I had never heard of ,a certain "Mrs Cheesebits" [no relation] who in the 70's used to sit cross-legged on a pavement all day [often sat immodestly] selling day-old copies of The Halifax Courier. Rumour had it that if she didn't bring home enough money, her son would beat her up in the evening... that's the way it goes.............*

While Googling "Tommy Cheesebits" I came across the strange tale of Charles Morritt, A.K.A. 'the Professor' : Morritt also knew the famous American escapologist Harry Houdini well. In fact he worked with Houdini for several years and sold him the secret of several tricks. Morritt's disappearing donkey trick was adapted by Houdini to create his famous vanishing elephant stunt. Sadly, after the Halifax court case in 1928 Morritt never worked again; his health and spirits had suffered too badly. He moved with his "wife" to Morecambe, where she set up in a booth as a fortune teller. Charles Morritt died in hospital in 1936.........(Halifax Courier)

Tony Zimnoch lives in the West Yorkshire town of Hebden Bridge. He has been blogging his unique combination of words and images and sounds since 2001.

Wendy Mathias : Jollett Etc

BREAKING THE ICE

This week's Sepia Saturday is a special day: it marks the 200th edition of Sepia Saturday. To commemorate this amazing milestone, participants have been invited to share ONE of their own favorite contributions which will be collected in a keepsake book.

As a family historian, I always try to link the weekly prompt to a family member and story. I chose the story about my dad's service in the Coast Guard for a couple reasons. First, my response to the original prompt forced me to do research, and I always appreciate that kick in the pants. Second, the process of writing the post made me see my dad, REALLY see him and his character in a way that I probably always knew subconsciously but had never thought about before. Besides all that, the photos themselves are rather interesting for their historic and cultural value.

When Alan selected the photo for this week's Sepia Saturday challenge, he was dreaming of his upcoming luxury vacation cruise. While I've never been on a cruise, my dad did some cruising.
He enlisted shortly after high school on February 11, 1946, and was honorably discharged May 12, 1947. One year in service to our country must have been the minimum to qualify for the GI Bill enabling him to enroll in college for the fall semester.

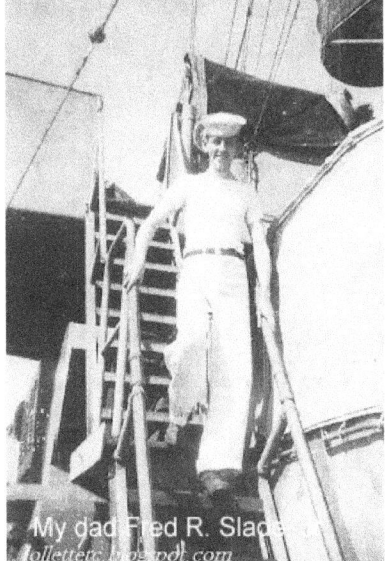

Daddy was stationed in Boston, Massachusetts. He loved Boston and he spent as much of his free time as possible at the Boston Symphony or at Fenway Park watching those Red Sox. His work as a seaman involved decommissioning four ships. I suppose that means he was cleaning out drawers and removing cannonballs preparing to spike the cannon.

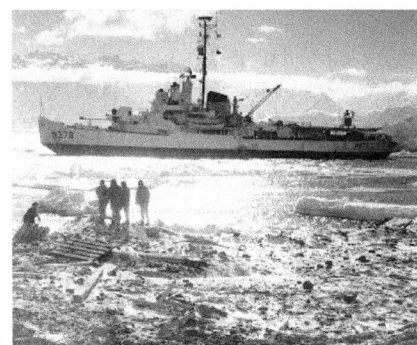

USCGC Eastwind photo courtesy of USCG.mil

He was assigned to the USCGC Eastwind, a wind-class icebreaker, considered the most technologically advanced icebreaker in its day. Icebreakers are special-purpose ships with a strengthened hull and an ice-clearing shape, with power to push through ice-covered waters.

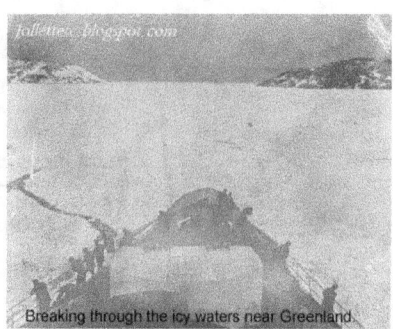
Breaking through the icy waters near Greenland

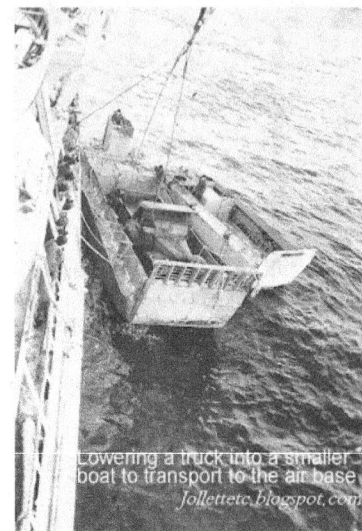
Lowering a truck into a smaller boat to transport to the air base

The Eastwind and ships like it were able to drive their bow onto the ice, breaking the ice under their weight. The specially designed hull enabled the ship to direct broken ice either around or under the vessel; otherwise the buildup of broken ice could slow it down.

The Eastwind made four trips to Greenland patrolling the waters, but mainly supplying bases there.

I don't ever recall seeing Daddy's scrapbook of his time in the Coast Guard until after his death. So I'm totally without stories about his shipmates and their work, which he faithfully documented in photos.

But the scrapbook reflects Daddy's personality and the traits that I have come to associate with him. First of all, he was always sentimental about mothers and children.

Inuit people of Greenland

Inuit family in front of their home

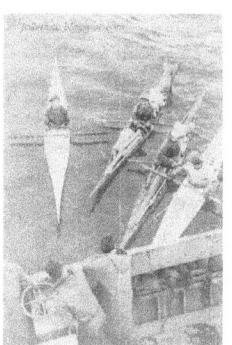

He was curious about other cultures. The powerful icebreaker held as much fascination for the Inuit as the kayaks did for Daddy and his shipmates. He was in awe of nature's majesty.

He was always amused by the antics of children and animals.

A most loved companion - "Skunk"

Skunk was the ship's mascot. Although mascots were not officially allowed, most captains turned a blind eye as long as the animal was cared for and boosted morale. And in typical mascot fashion, Skunk didn't belong to anyone in particular and would follow along with the men when they went ashore, even to the bars. The men made sure Skunk sat on his own bar stool and drank some beer. Yeeeaah, I guess there was no PETA chapter in Thule.

Wendy Mathias is a retired teacher living in Chesapeake, Virginia. She has been a family history blogger for two years but a researcher of her various family lines much longer. When she's not trying to make sense of the many photos passed down to her, Wendy and her husband enjoy traveling, visiting wineries, and cruising around Smith Mountain Lake in their pontoon.

www.ingramcontent.com/pod-product-compliance
Lightning Source LLC
Chambersburg PA
CBHW081050170526
45158CB00006B/1925